IMAGES
of America

HISTORIC MOVIE
HOUSES OF AUSTIN

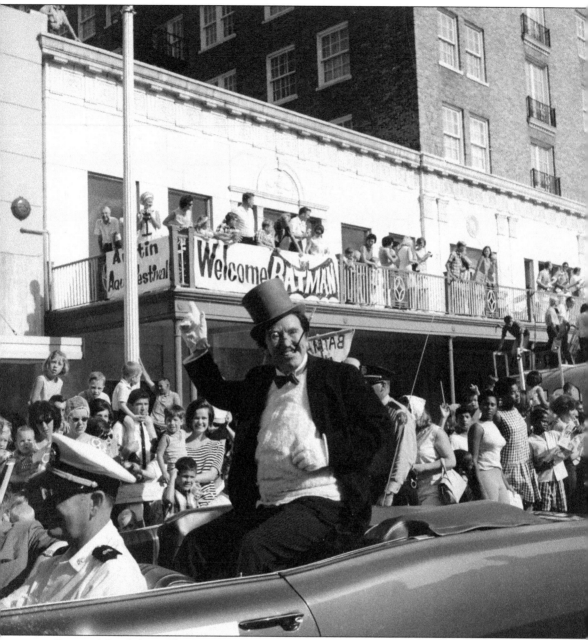

Burgess Meredith, as The Penguin, waves to the crowd for the world premiere of *Batman: The Movie* at the Paramount Theater on July 30, 1966. (Austin History Center, Austin Public Library ND-66-366-07.)

ON THE COVER: The Paramount Theater is pictured at night around 1936. Located in the heart of downtown Austin at 713 Congress Avenue, this iconic and beloved theater was built in 1915 and is listed in the National Register of Historic Places. (Austin History Center, Austin Public Library PICA 32942.)

IMAGES
of America

HISTORIC MOVIE HOUSES OF AUSTIN

Susan B. Rittereiser, Michael C. Miller,
and the Austin History Center

ARCADIA
PUBLISHING

Published by Arcadia Publishing
Charleston, South Carolina

Printed in the United States of America

Library of Congress Control Number: 2016947865

For all general information, please contact Arcadia Publishing:
Telephone 843-853-2070
Fax 843-853-0044
E-mail sales@arcadiapublishing.com
For customer service and orders:
Toll-Free 1-888-313-2665

Visit us on the Internet at www.arcadiapublishing.com

*To the theater operators and moviegoers of
Austin, Texas—past, present, and future.*

CONTENTS

ACKNOWLEDGMENTS

This book was completed as a project for the Austin History Center (AHC), and as such, we are very thankful to the entire staff at the AHC, especially when we were perhaps a little distracted by this project. We are especially thankful to exhibits coordinator Steve Schwolert, who designed the exhibit that led to this work, and to archives media specialist Grace McEvoy, who took many of the pictures used in the exhibit and this book.

All the images used in this book come from the Austin History Center, Austin Public Library (which will subsequently receive all the book royalties). The image citations refer to the photograph collection that contains the image. Most come from the General Collection and are identified as PICA, PICB, or PICH, or begin with AF. We are especially thankful to Austin theater projectionists Jim Maloy and John Stewart for making many of these images available to the archives. Other important collections used include the Neal Douglass Photography Collection (citations begin with ND), the Russell Chalberg Collection of Prints & Negatives (citations begin with C), and the *Austin American-Statesman* Negative Collection (citations begin with AS; images used with permission).

We also made extensive use of a few manuscript collections at the AHC that exist because of the generosity of families of Austin theater operators. These are identified by their collection number in the text. We are particularly thankful to Jay Podolnick, son of Earl and Lena Podolnick, who donated the records of Trans-Texas Theater Inc. (AR.2012.004). The Hegman family also donated images that form part of the Jay J. Hegman Papers (AR.2012.009). We also used many photographs from the Paramount Theater Inc. Records (AR.2001.018), the Crowe Photography Collection (AR.2014.035), the Wukash & Associates Records (AR.2009.042), and the David N. Smith/KTBC Papers (AR.1997.012).

INTRODUCTION

The development of the modern cinema spans over a century and was the result of a series of technological innovations that occurred throughout the 19th century. One of the most important of these was by Etienne-Jules Marey, a French physiologist who, in 1882, recorded the first series of photographs of animal locomotion in a single, portable camera, the chronophotographic gun. By using roll film rather than cumbersome photographic plates like his predecessors, Marey has the important distinction of introducing the film strip to cinematography.

In June 1889, the American inventor Thomas Alva Edison assigned his laboratory assistant William Kennedy Laurie "W.K.L." Dickinson the task of developing a motion picture camera that would provide visual accompaniment to his wildly successful invention, the phonograph. The result was the Kinetograph, introduced in late 1891. Mistakenly assuming that the future of motion picture viewing lay in individual exhibition, Edison asked Dickinson to develop a personal viewing device to display his Kinetograph movies. The device, called a Kinetoscope (*kineto* meaning "movement" and *scopos* meaning "to watch"), consisted of a large wooden box with a small magnifying lens on top for viewing. A continuous 40- to 50-foot film strip ran on spools between an electric lamp and a shutter inside the box. By 1893, Edison began marketing the device to several companies. One year later, on April 14, 1894, the first Kinetoscope parlor was opened in a converted shoe store at 1155 Broadway in New York City.

By 1895, over 900 Kinetoscopes had been sold in the United States and installations had reached a saturation point. Edison learned that two young inventors, C. Francis Jenkins and Thomas Armat, had successfully projected a series of Kinetograph shorts with an electrically powered machine. He was so impressed with their device that he bought it outright and coined it the Vitascope. The first public exhibition of the Vitascope was given on April 23, 1896, at Koster and Bial's Music Hall in New York City, where it received top billing as "Edison's latest marvel." The first storefront theater in the United States dedicated exclusively to showing motion pictures was Vitascope Hall, established in a vacant store on Canal Street in New Orleans on June 26, 1896. Austin had only one known Kinetoscope parlor, the Phonograph Parlor at 717 Congress Avenue, which was open from 1897 to 1898.

Motion pictures came to Austin in 1896, debuting at the Hancock Opera House. A short film was projected as part of a vaudeville act. For the next 11 years, moving pictures made sporadic appearances in Austin, usually at the Hancock or Millett Opera Houses. Sometimes, they were part of traveling shows associated with festivals. These films were usually shown at the end of vaudeville acts or during intermissions. Early films were sometimes called "chasers," because once the novelty of moving pictures wore off, few people stayed for the movie, and theater managers used the films as a signal that the live show was over to "chase" the audience from the theater.

The Hancock offered a mix of live and film entertainment, with movies Wednesdays through Saturdays and vaudeville and other live performances all other times. On September 17, 1913, the *Austin Democratic Statesman* advertised the first "talkie" in Austin, calling it the "perfect synchronization of voice and action." Many theaters through the years would claim to be the first to show movies with sound.

The popularity of projected motion pictures for entertainment soon gave rise to the nickelodeon (from the word nickel plus *odeon*, the Greek word for theater), a multipurpose theater that charged a nickel for admission and featured other forms of entertainment as well, such as lectures, illustrated songs, and slide shows. By 1908, there were 10,000 nickelodeons operating in the United States. Studios could barely keep up with the public appetite for new films. Small theater ventures took over storefronts along Congress Avenue and Sixth Street, offering Austinites a chance to see films. Storefront theaters usually consisted of a few rented or borrowed chairs, a white sheet hung along one wall, and a hand-cranked projector on a table. Nickelodeons ran much like the storefronts, but showed movies seven days a week, usually more than 10 shows a day. They were often billed as family-friendly attractions, with some advertisements encouraging parents to send children to the theaters alone as management would "pay close attention to the little ones." Nickelodeons usually made use of existing buildings and storefronts to show movies.

By 1911, movies took top billing to vaudeville. This year also marked the introduction of the Kinemacolor process, a machine-coloring process that made color films feasible. Also, area churches started showing films, perhaps as a counter to the 96 saloons in Austin. Some theaters started showing "Photo-Sermons" on Sunday, usually free because the existing blue laws did not allow the theaters to charge admission on Sundays.

Nickelodeons started giving way to "movie houses" with the advent of full-length narrative films, whose length required more comfortable settings than could usually be found in the small nickelodeon theaters. D.W. Griffith's *The Birth of a Nation* helped usher in this change. Films were no longer "nickel" affairs, but were billed to a richer clientele, with Griffith's film showing at the Hancock on October 31, 1915, for $2 admission. As the film industry became a legitimate entertainment source for consumers, architects began designing "movie palaces" to maximize the movie-going experience. Some were still designed to be multipurpose, perhaps out of fear that movies would not completely replace live theater as the preferred entertainment.

Once it was clear that movies were here to stay, it was not long before the exhibition of films took on a corporate look. The Interstate Theater Circuit (ITC) was the first corporate movie house company to move into Austin in the early 1930s, taking over a few existing theaters while also expanding the film-going options by building additional theaters. The ITC operated during the time that movie studios controlled the distribution of their films, giving them a near monopoly on first-run feature films. This left the independent operators, such as the Hegman family and Richard "Skinny" Pryor, fighting over films from smaller studios or second-run features. When the Supreme Court broke up the hold that studios had on distribution in the 1940s, the air was cleared for more companies to open movie houses. Austin produced a number of these companies, such as Trans-Texas Theaters Inc., Eddie Joseph Theaters, and Presidio Theaters.

Throughout the history of film, at least during the age of the single-screen theater, the movie house experience proved to be almost as important and memorable. Even today, with so many options available for people to experience a movie, people still enjoy and often prefer the cinema-going experience over watching on their televisions, computers, or phones. For more than 100 years, movie house operators and staff have worked hard to make the cinema experience memorable for Austinites.

One

EARLY CINEMA

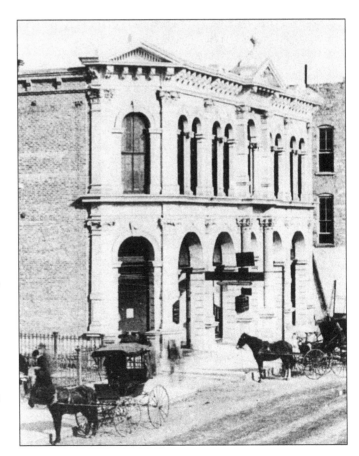

Motion pictures came to Austin on October 10, 1896, debuting at the Hancock Opera House, located at 112–114 West Sixth Street. The Hancock began showing movies as part of its regular billing in 1910 and was the first theater to permanently install a movie projector. The Hancock is pictured here around 1900. (PICA 18462.)

The Casino Theater opened in 1909 as the Popular #2 at 702 Congress Avenue. The theater was taken over by Wishert & Marshall Amusement Company shortly after opening. Ewald Besserer was the musical director of the company and became Marshall's partner in 1910, renaming the company Besserer and Marshall. They also ran the Playhouse, Princess, and Texas Theaters. The Casino closed in 1924. (PICB 07284.)

The Texas Theater was one of three theaters run by the Besserer and Marshall Company. It opened in 1911 at 804 Congress Avenue and closed in 1918. Richard "Skinny" Pryor took over operations sometime in the mid-1910s. Pryor, a former vaudeville performer, ran many theaters in Austin well into the 1930s. This photograph was taken around 1916. (PICA 06737.)

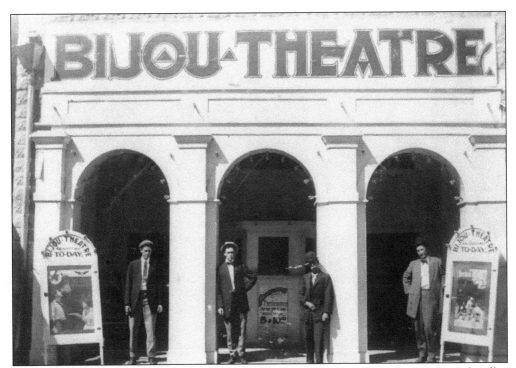

The location of the Bijou Theatre is unknown, though one source indicates it was across the alley from Scarbrough's Department Store on Sixth Street. The theater does not appear in the city directories and appears to have been short-lived, as many early theaters were. (PICA 06736.)

Like many commercial operations, running a movie theater required a city license. Besserer and Marshall paid $6 in 1911 to be able to run their theaters for six months. Their offices were next door to the Yale Theatre. (AF-M8300[15]-001.)

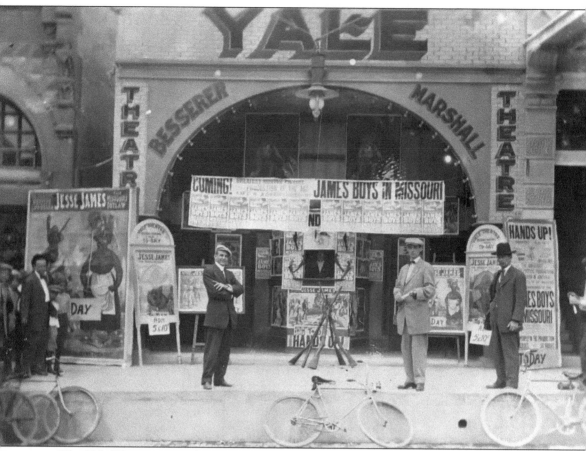

The Yale Theatre opened in 1909 at 618 Congress Avenue. It was home to the first Texas showing of *Roosevelt in Africa*, a film showing Teddy Roosevelt's hunting exploits in Africa. This photograph was taken in 1911 and shows Ewald Besserer at far left (in front of the Jesse James sign) and William Marshall second from right (in front of the "HANDS UP!" sign). The Yale closed in 1911, one of about a dozen that came and went. Others, not pictured in this book because no photographs could be found, include the Bell Air Dome on West Ninth Street, Cameraphone Theater on West Sixth Street, Colonial Theater at 916 Congress Avenue, Creek Theater on East Sixth Street, Empire Theater at 715 Congress Avenue, Flury Godfrey Theater at 1102 East Eleventh Street, Gibson & Allred Theater at 2208 Guadalupe Street, Happy Land Theater at 500 East Sixth Street, Midget Airdome at 403 Congress Avenue, Pasttime Theater at 115 West Sixth Street, the Playhouse at 621 Congress Avenue, the Popular Theater at 619 Congress Avenue, Star Theaters #1 (818 Congress Avenue) and #2 (211 East Sixth Street), and the Wonderland Theater at 113 West Sixth Street. (PICA 06745.)

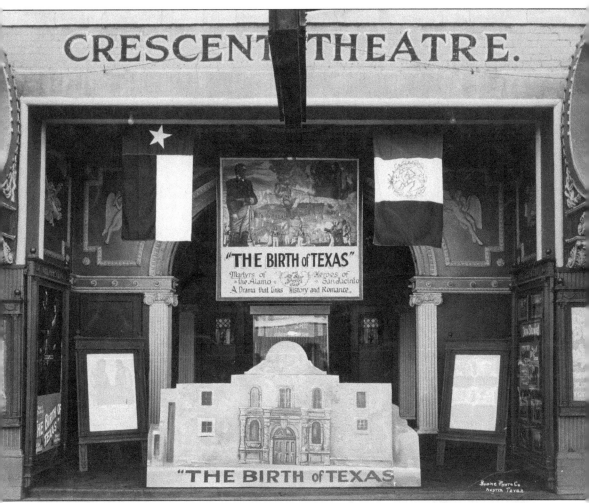

The Crescent Theatre, located at 920 Congress Avenue, was opened in 1913 by MacCormack & Company. Newspaper advertisements touted this as the first theater built to show movies. The Crescent featured films produced by Thomas Ince, such as *The Cup of Life* and *The Devil* starring Bessie Barriscale. While the film company did not have control over which movies were shown there, this arrangement foreshadowed the age of cinema where Hollywood studios owned their own theaters and held tight control over where their films were shown. Ince himself fell victim to the rise in power of the Hollywood studios, and his studio in Culver City, California, became home to MGM. This c. 1916 image shows the Crescent screening the film *The Birth of Texas* (also known as *Martyrs of the Alamo*), a 1915 film about the battle of the Alamo directed by Christy Cabanne. (PICA 38439.)

13

A *Political Touchdown* premiered at the Crescent in 1925. This was the first photoplay to "star" Austin. It was produced for the Austin Chamber of Commerce by Paragon Feature Film Company. The climax of the film was the burning down of the governor's mansion. The Crescent was one of the last theaters of this era to close, showing its last movie in 1931. (PICA 06735.)

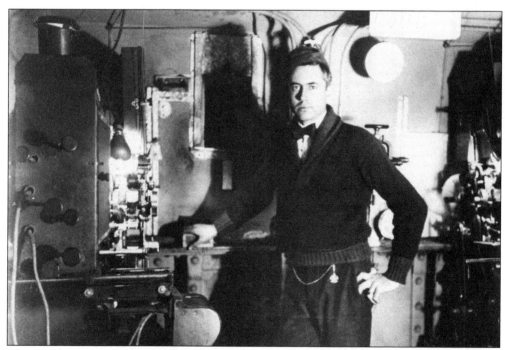

John Beckham, pictured here in the projection booth at the Crescent, was a longtime projectionist in Austin, beginning his career at the Crescent. He also worked at the Queen Theater, where he lost a finger in the projector. He died on December 1, 1969. (PICA 36760.)

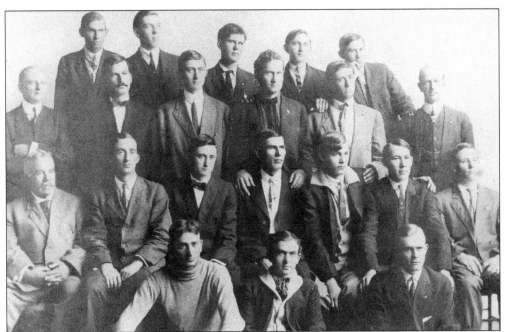

The International Alliance of Theatrical Stage Employees (IATSE), Local 205, formed in 1911 as a labor union representing laborers in the entertainment industry, including moving picture theater projectionists. The image above shows members of IATSE Local 205 in 1912, including noted Austin theater operator Richard "Skinny" Pryor, seen here at far right in the third row. In addition to representing projectionists, the local also sponsored fun events, such as the Midnight Banquet in 1919 at the Majestic Theater, pictured below. The IATSE banquet included projectionists, film salesmen, stagehands, and owner operators from the Queen, Casino, Majestic, Grand Central, Crescent, and Hancock Theaters. The banquet was held on the Majestic's stage. (Above, PICA 36761; below, AR.2012.009[021].)

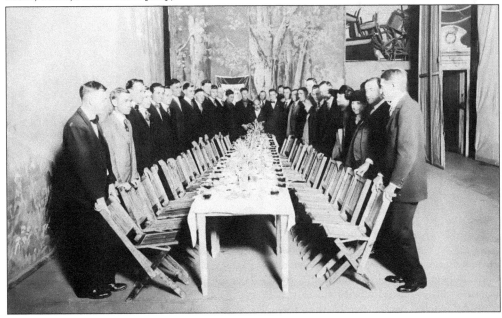

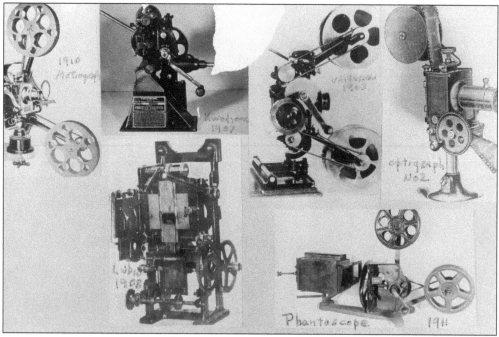

Early projectionists had a host of projectors to operate, and it seemed like the technology was changing almost daily. This c. 1912 picture shows just six of the more than a dozen different types of projectors used in these early days of motion pictures. The image shows (clockwise, from top left) the Motiograph (in use in 1910), the Kiwadiome (1907), Universal (1903), Optograph (1902), Phantascope (1911), and the Lubio (1908). (PICA 36759.)

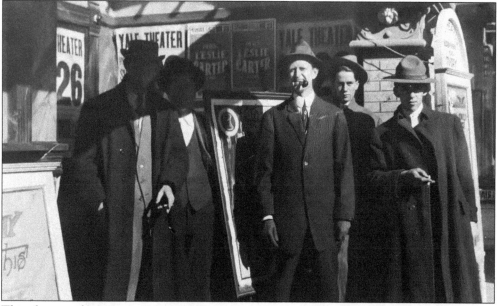

This photograph's caption, "Movie Operators—$4.00 week," is perhaps alluding to their pay. In today's dollars, that would be about $100 a week—certainly not a livable wage. This image shows, from left to right, two unidentified, Skinny Pryor, Paul Tilley, and Bob Rockwood standing in front of the Yale Theatre in 1910. (PICA 37205.)

16

Brothers Paul (below) and Wesley Hope Tilley (right) were pioneer Texas filmmakers, producing silent films in Houston and San Antonio before settling in Austin. Their film company, Satex Film Company, started when the brothers were in San Antonio (thus the name), and their earliest films were shown on a screen in front of the Alamo. They moved Satex to Austin in 1913 and became the first film company in the United States to produce three-reel films. The company folded the same year, and Hope Tilley remained in Austin, working as a music teacher. He, along with his wife, Helen, often played live accompaniment to silent movies all over town. (Right, PICB 21578; below, PICB 21575.)

Paul Tilley, following the closure of the Satex Film Company, moved to California and became an artist, known mostly for his landscape paintings. He also continued to work in film, including working on projects with director and fellow Texan King Vidor. He is seen here working the projector at the Yale Theatre around 1912. (PICB 21577.)

W. Hope Tilley, shown here working on a film with Charles Pyle, lived in Austin until his death on June 24, 1972. After leaving the film business, he worked as a music teacher and a musician, including running his own music studio, Tilley Music Studio, until 1970. (PICA 20477.)

Two

THE PALACES

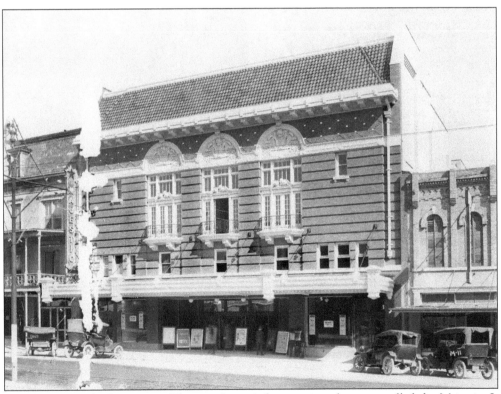

Now known as the Paramount Theater, Austin's first movie palace was called the Majestic. It had its grand opening on October 11, 1915, with a standing-room-only crowd for the comedy play *When Knights Were Bold*. Most tickets sold for 25¢ each. That night, prolific theater designer John Eberson, known as "Opera House John," proclaimed his creation to be "one of the best theaters in the country." (C062326.)

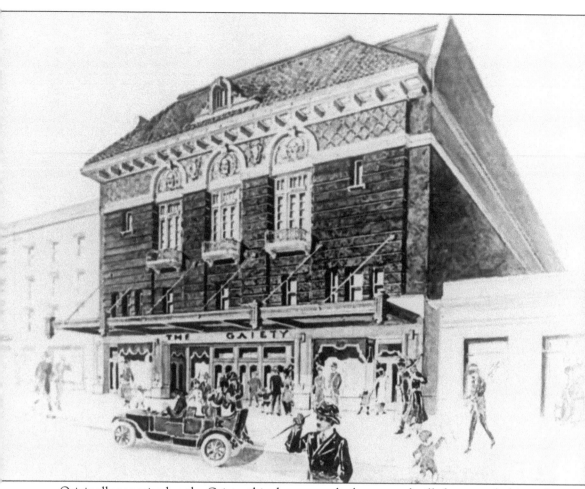

Originally conceived as the Gaiety, this theater was built as a vaudeville house and ultimately christened the Majestic because it was part of the national Majestic Vaudeville Circuit. Chicago-based Eberson had already designed many theaters across Texas for the Interstate Theater Circuit, a vaudeville company run by Karl Hoblitzelle out of Dallas. Interestingly, Hoblitzelle's ITC eventually acquired the Paramount in 1933 (see more on Hoblitzelle and the ITC in chapter three). (PICA 12723.)

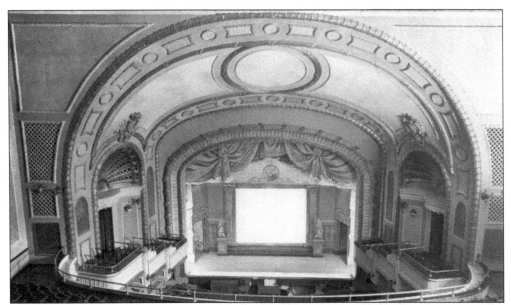

Located in the heart of downtown at 713 Congress Avenue, the Majestic was built in just eight months by Austinite Ernest Nalle at a cost of $150,000 (about $3.5 million dollars today). The Neoclassical-style theater boasted an in-house Estey pipe organ and a lavish interior with 1,316 seats. The stage and movie screen were handsomely framed by an ornate proscenium arch. Still in use today is the theater's original "hemp house" system of ropes, pulleys, and sandbags, which are used to "fly" scenery on and off the stage, as well as the hand-painted landscape fire curtain (not pictured). Discovered in the mid-1970s hanging from the rafters in near perfect condition, the fire curtain is considered one of the oldest remaining such curtains in the country. (C02673.)

Although the emphasis was on live performance, the Majestic also offered silent film showings accompanied by the pipe organ, which was designed to produce varied sound effects during a picture show. Large ceiling fans were placed throughout the auditorium for maximum cooling during the hot Austin summers. (C01137.)

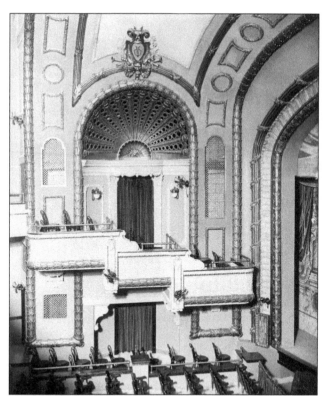

In grand opera house style common at the time, the theater offered luxurious opera box seating, as shown here. Considered the most prestigious seats in the house, they were located to the front, side, and above the level of the stage and provided the best overall experience of a performance. They were removed in the 1930s and then later put back in the late 1970s. (C02677.)

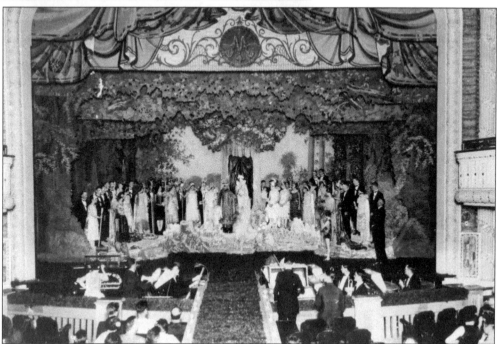

The box seats are partially visible on either side of the stage in this unidentified theater production. A small orchestra sat directly in front of the stage, as did the pipe organist, shown to the left of the stage. (PICA 18224.)

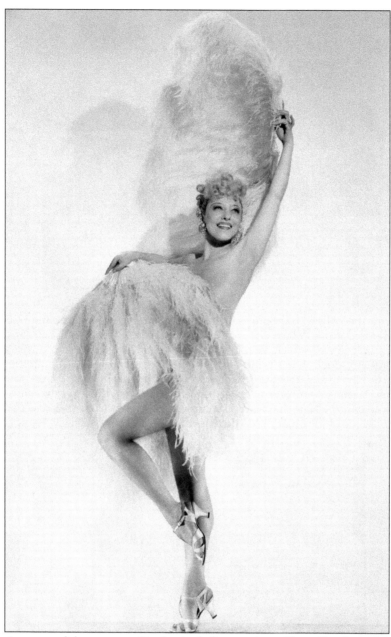

The Majestic attracted the top acts of its day, including magician Harry Houdini, who performed eight successive sold out shows to nearly 20 percent of the city's population in 1916 (about 7,000 people). Other acts included the Ziegfeld Follies, Sarah Bernhardt, and burlesque dancer Sally Rand, pictured here. Rand was known for her risqué ostrich feather fan dance in which she created the illusion of nudity by wearing a flesh-colored body suit and dancing under a blue spotlight while playing peek-a-boo with the feathers. Local lore has it that a young Charles Root, who would later become the manager for Interstate Theaters in Austin, was operating the lights the night Rand performed at the Majestic. He mistakenly used a white light on her rather than a blue one, which temporarily ruined the illusion. She cursed him out like a sailor in front of the audience before resuming her act as if nothing happened. (PICA 08805.)

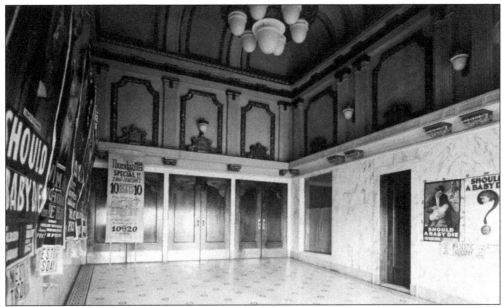

Pictured here is the lobby with the original Spanish tiled floor and posters for the 1916 silent film provocatively titled *Should A Baby Die?*, one of two featured shows for the "Thursday special." As noted in the poster on the back left door, shows cost between 10¢ and 20¢ each. Movies were shown using two projectors (one shown below), which were housed in a fireproof projection room for safety purposes. Nitrate film, as was used at the time, was so highly flammable that, once ignited, it could continue burning even when submerged under water. It could also spontaneously combust if stored in hot conditions. Note the camera is facing down; this is because the projection room was located near the top of the house above the upper balcony. (Above, C06829; below C02675.)

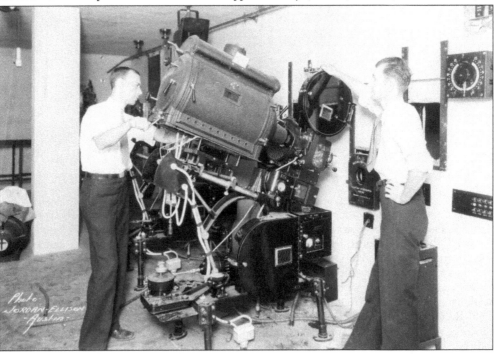

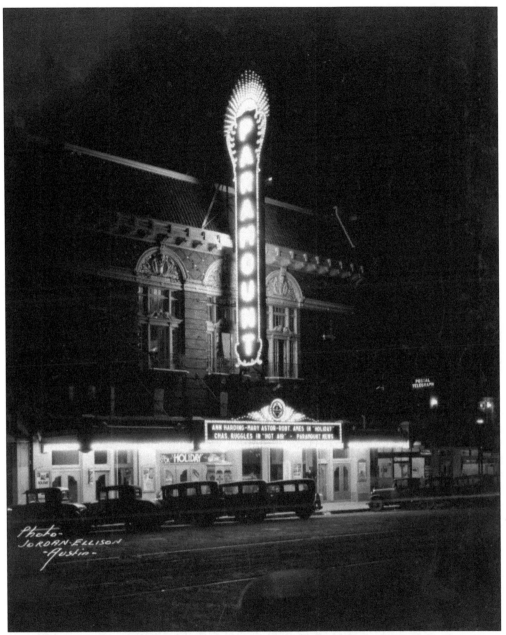

With the advent of synchronized sound in movies, or talkies, in the late 1920s, the theater saw increasing success. In a move to ensure its survival following the stock market crash of 1929, the Majestic transformed from a vaudeville house into a grand movie palace. It was given an extensive makeover and reopened as the Paramount in 1930. It also continued to offer live entertainment throughout the 1940s. Originally part of the Publix theater chain, Publix became a subsidiary of Paramount, hence it was named after its new owner, Paramount-Publix. The distinctive Paramount blade was erected, and the theater started showing only Paramount studio pictures. During this time, it was commonplace for movie studios to own movie theaters, which allowed them to control the distribution of their own motion pictures. The US Supreme Court put a stop to this practice in 1948. (C06839.)

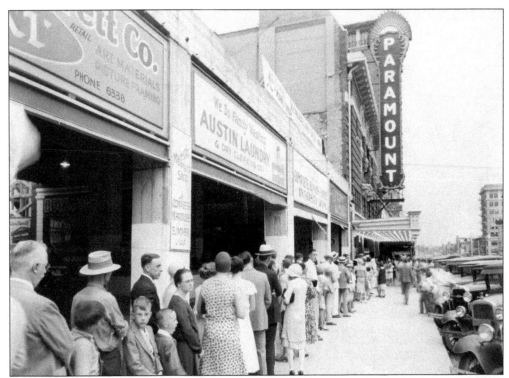

Fortunately for the Paramount (and other Austin-based theaters), the advent of sound coupled with the harsh economic realities of the Great Depression actually helped bolster demand for movies among a public hungry for diversion through escapist entertainment, as this photograph from the early 1930s clearly demonstrates. In 1934, the Paramount became the first theater in Texas to introduce Wide Range, a new sound technology from Western Electric Sound. (C06837.)

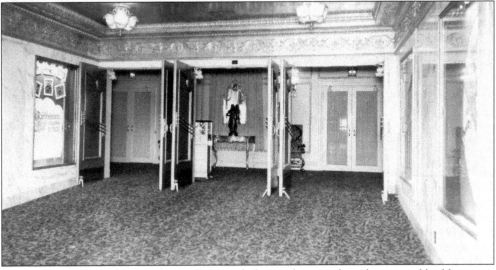

The theater was remodeled in the Art Deco style for nearly as much as the original building cost. Improvements included modern, luxurious upgrades, such as a state-of-the-art sound system, air conditioning (movie theaters were among the few places at the time equipped with air conditioning), and wall-to-wall floral carpeting in the first (shown here) and second lobbies. (C06832.)

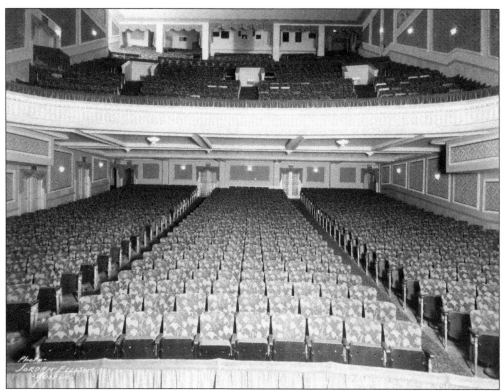

Plush, upholstered seats replaced the wooden ones, as shown in this view looking out over the auditorium from the stage; floor seating was expanded. The fancy, opera-style box seats were removed from the sides of the auditorium because it was thought that the sight lines were not good for watching movies. Note the projection booth (see page 24), located above the upper balcony seating. (C06827.)

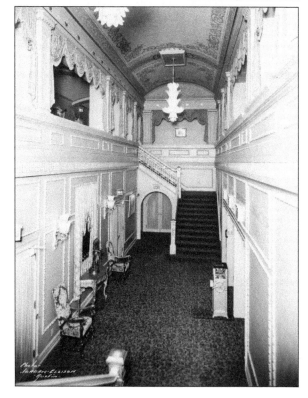

Drapery adorned doorways and windows; new, petal-shaped chandeliers and decorative wall sconces were placed throughout, as can be seen in this photograph looking down at the second lobby from above. (C06834.)

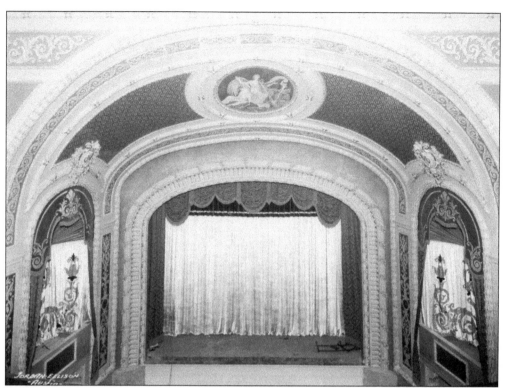

The grand proscenium arch was painted gold and a medallion of Saint Cecilia, the patron saint of music, was painted above the arch. Urban legend has it that when Harry Houdini performed at the theater in 1916, he had his crew drill a hole in the ceiling above the proscenium for one of his escape tricks, and the hole was never fixed. The "Houdini Hole" can be seen below to the left of St Cecilia's free hand, past the medallion's borders. (Above, C06828; below, PICA 36801.)

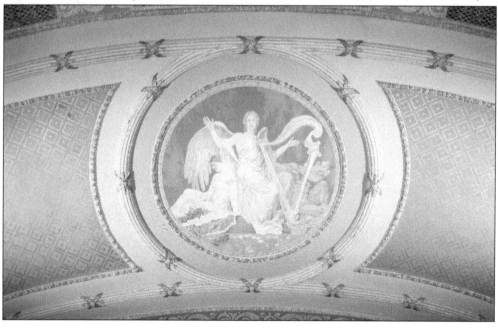

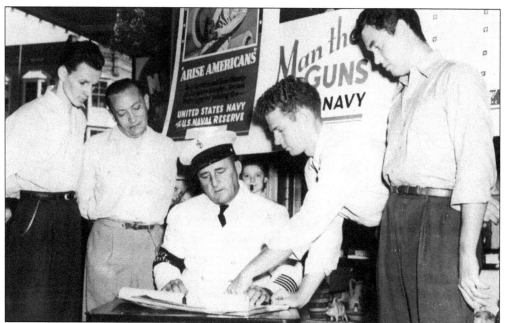

During the 1940s, the Paramount was owned by Karl Hoblizelle's Interstate Theater Circuit. In keeping with the company motto "Dedicated to Community Service," the theater was a big promoter of war bonds. It sold $8.4 million worth from the first drive in 1942 until the very end of the war in 1945. It also ran films to recruit and train people for the war. *Paris Under Ground*, *G.I. Joe*, and *Pride of Marines* were all shown at the Paramount. Above, Louis Novy, city manager for ITC's Austin theaters, looks over the shoulder of a US Naval recruiter in the process of enlisting three young men. In July 1945, Novy was awarded a war finance silver medal by the US Treasury War Finance Committee in recognition of the number of war bonds sold by the Paramount. Novy, a Russian immigrant, was known throughout the community for his patriotism and financial generosity toward soldiers stationed in the area. (Above, AR.2012.004[084]; below, AR.2012-004[086].)

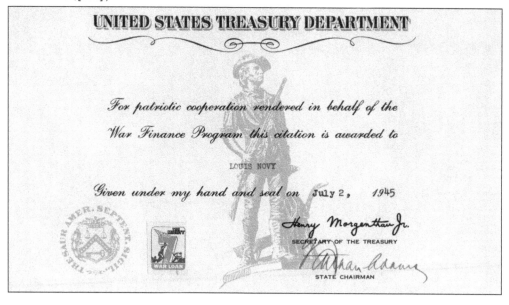

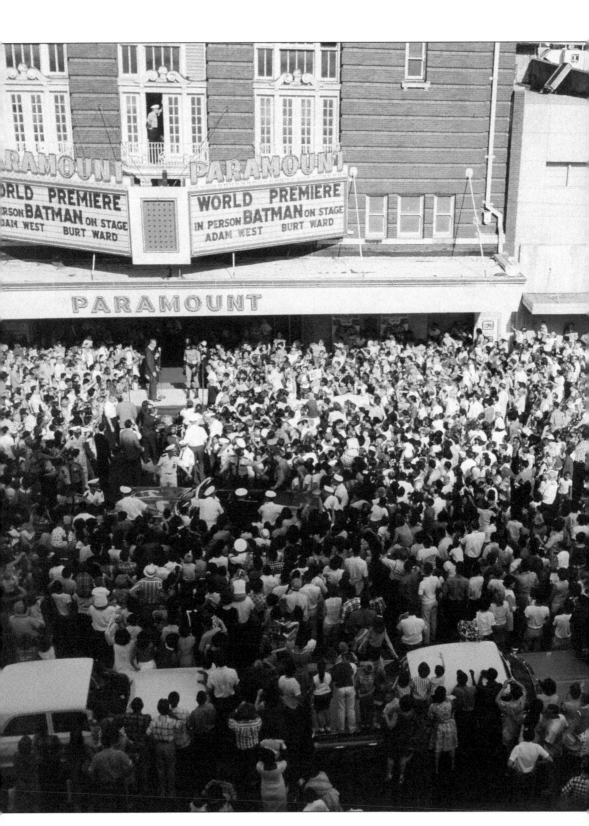

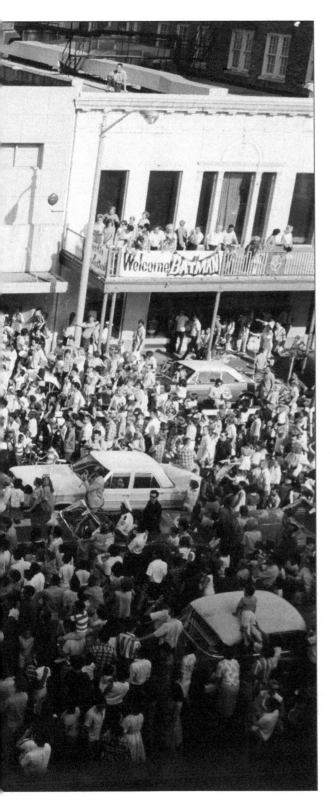

In what was perhaps the most successful movie event in Austin's history, the Paramount hosted the world premiere of *Batman: The Movie* on Saturday, July 30, 1966. An estimated 30,000 people—kids and adults—filled Congress Avenue, renamed Batman Boulevard for the occasion, to get a glimpse of the stars from the popular television series arriving by motorcade 30 minutes before the afternoon show. Adam West (Batman), Lee Meriwether (Catwoman), Burgess Meredith (The Penguin), and Caesar Romero (The Joker) appeared in full costume on a stage in front of the theater (in the sweltering Texas summer heat, no less). The premiere was intended as a pre-festival benefit for the city's annual Aqua Festival, with proceeds going to help keep the festival afloat for years to come. The Batboat featured in the movie had been designed by local boat company Glastron and was on display inside the theater during the premiere. (ND-66-290-03.)

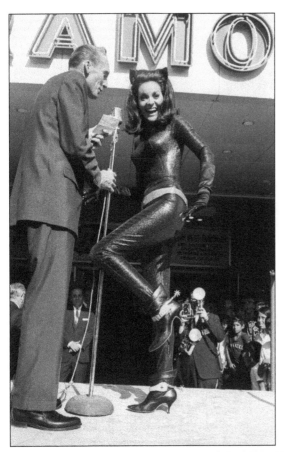

Lee Meriwether as Catwoman gives an interview for television. The former Miss America was given "honorary Texan" status (as were the other cast members) and gifted a pair of western spurs, which she incorporated into her cat costume. She replaced Julie Newmar, who played Catwoman in the television series. Meriwether actually did appear on the TV series twice in 1967, not as Catwoman, but as Bruce Wayne's love interest Lisa Carson. (AS-66-54995-10.)

Two showings were scheduled. At 5:00 p.m., there was an unprecedented "Young People's Premiere"—the first in the history of the industry, according to a 20th Century Fox spokesman— and a regular evening performance for adults at 8:30 p.m. Tickets cost $3 each. The first 500 ticket buyers for each showing received free "Batbuttons" emblazoned with the familiar Batman logo. (AS-66-54955-06.)

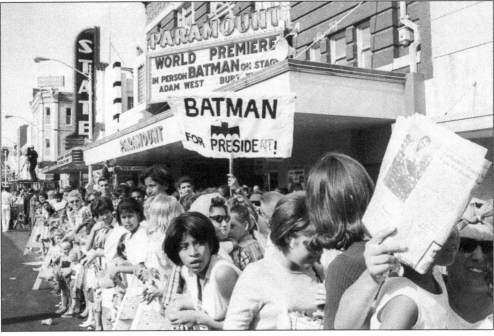

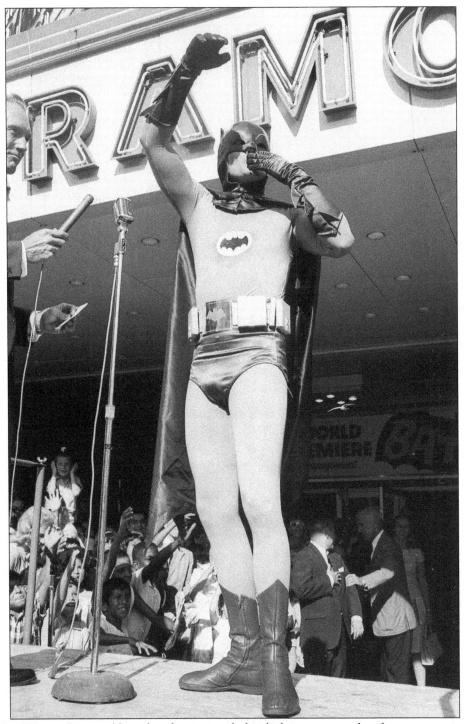

Adam West, as Batman, blows the adoring crowd a kiss before going into the afternoon premiere at the Paramount. The theater was filled to capacity for both the afternoon and evening performances. The caped crusader was minus his young sidekick, Robin, played by actor Burt Ward, because Ward's wife was in delivery with their first baby. (AS-66-54955A-01.)

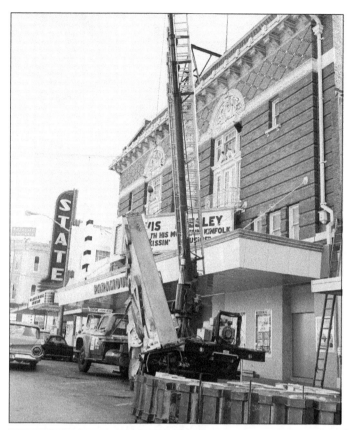

Despite the huge success of the Batman premiere, the theater's glory days were over. Ticket sales had been declining since the 1950s as television watching became a household pastime and families chose to go to the more conveniently located theaters out in the suburbs. ABC bought the theater along with other Interstate Theater Circuit assets. In 1964, the iconic Paramount blade, considered a Congress Avenue landmark for decades, was taken down to be refurbished, never to be seen again. By the time the photograph below was taken in 1973, the theater was showing B-films to a largely nonexistent audience and was in danger of being demolished for a Holiday Inn. (Left, AS-64-44896-01; below, AR.2013.029[096].)

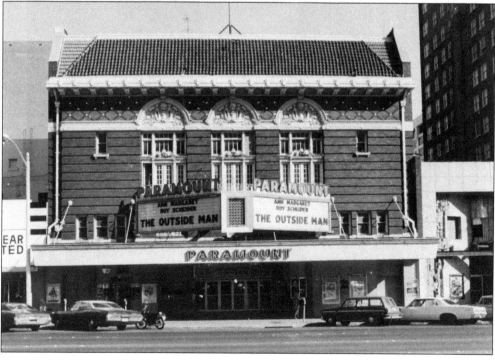

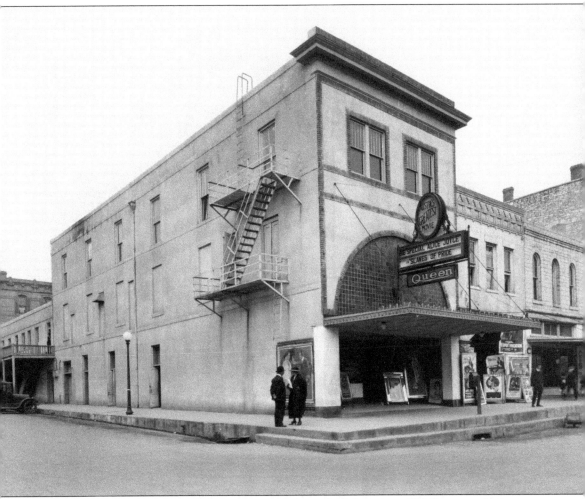

The Queen Theater was located across the street from the Majestic at 700 Congress Avenue. Originally called the Lyric, it was bought by Maj. George W. Littlefield, who also purchased the Casino Theater next door at 702 Congress Avenue. Pictured here is the "old Queen" in March 1920, around the time Littlefield announced his plans to tear down both theaters and build a new Queen Theater. (C01109.)

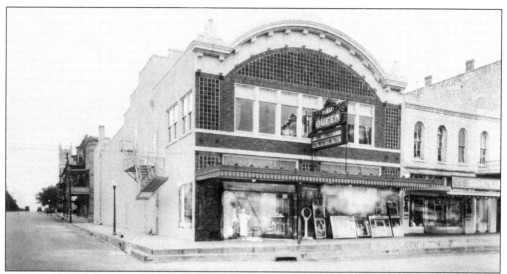

Littlefield died before his plans were realized, but the project was completed under the leadership of the old Queen manager, Jay J. Hegman. "Hegman's Queen" opened in February 1921 to the tune of $200,000. Touted in the *Austin Statesman* as a "first-class theater house" built specifically for showing "high class motion pictures," provisions were made for accommodating vaudeville acts as well if future need arose. (C02261.)

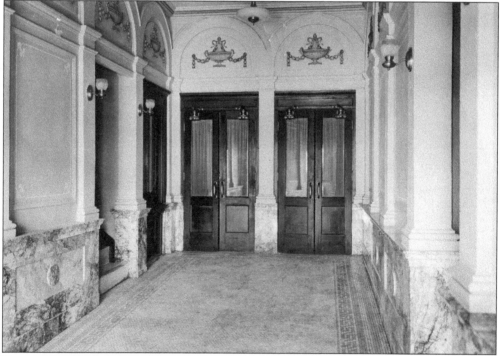

Designed by Walsh & Geisecke, no expense was spared in order to make the average theatergoer feel like royalty. The construction featured elaborate marble wainscoting around the perimeter of the building as well as throughout the auditorium and the foyer, pictured here. The foyer was tinted baby blue and contained statues placed in arched niches in the walls on both sides. (AR.2012.009[007].)

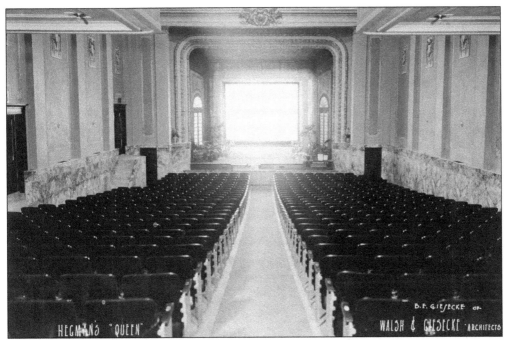

There were a total of 900 seats, 560 of which were on the first floor, featuring seat coverings with the theater's embroidered initials and upholstered spring air cushioning, complete with hat racks (as everyone wore hats in those days) and expansion bolts. The flooring had countersunk rubber for eliminating sound when walking down the aisles. In order for every customer to have an unobstructed view of the screen, the floor was constructed at an incline of seven feet from the stage to the entrance, as can be seen in the photograph below. Immediately underneath and to the center of the balcony is the fireproof (concrete) projection room. This location enabled films to be projected onto the screen without interference from people looking for seats passing in front of the projector, a common occurrence in movie houses at the time. (Above, PICA 06728; below, PICA 36764.)

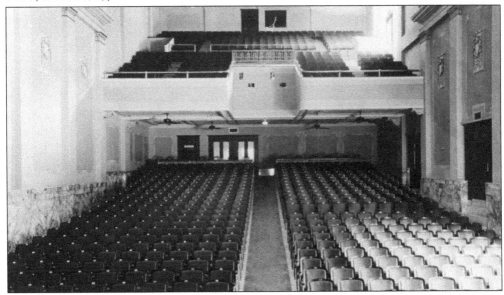

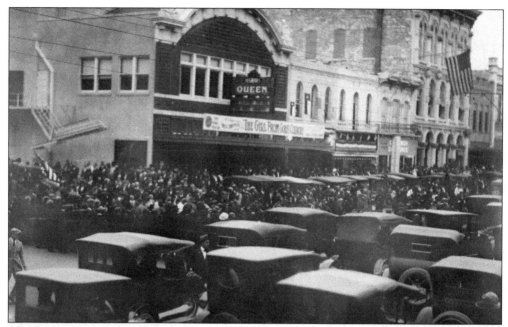

The flag-waving crowd and traffic jam along Congress Avenue pictured here are likely associated with an event at the Texas State Capitol, located just five blocks north of the Queen Theater, in conjunction with Armistice Day (now called Veteran's Day). *The Girl from God's Country* played the same week that the US Congress declared November 11, 1921, a legal federal holiday recognizing all those who fought in World War I. (C00629.)

Crucial to the success of a movie palace was its ability to provide good musical accompaniment for its motion pictures. The new Queen featured a massive Robert Morton pipe organ. Two musicians were hired to play it to ensure continuous music throughout a performance. This photograph was taken by Wesley Hope Tilley, who was the featured organist on the sign. He, along with his wife, Helen, provided musical accompaniment for many theaters around town. (PICA 06741.)

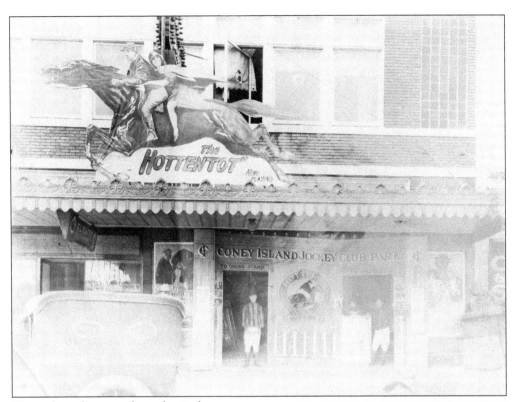

Pictured are doormen dressed as jockeys under an impressive marquee for the 1922 film *The Hottentot*. The movie is about a horse-phobic young man who is mistaken for a famous jockey and is eventually forced to substitute for him in a race riding a wild stallion known as the Hottentot. (AR.2012.009[016].)

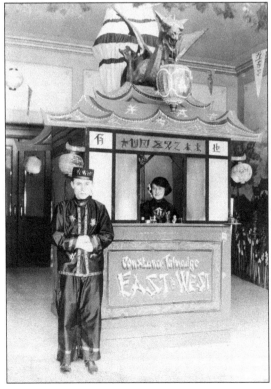

Hegman's Queen went the extra mile in creating a fantasy environment meant to attract moviegoers by elaborately decorating the interior and exterior of the theater, as well as its staff, to match the themes of the movies it showed. Pictured here outside the front of the theater is an usher/doorman (customers were given "royal treatment" by having doors opened for them) and ticket taker in Asian costumes for the 1922 silent film *East is West*, starring the very popular Constance Talmadge. (AR.2012.009[019].)

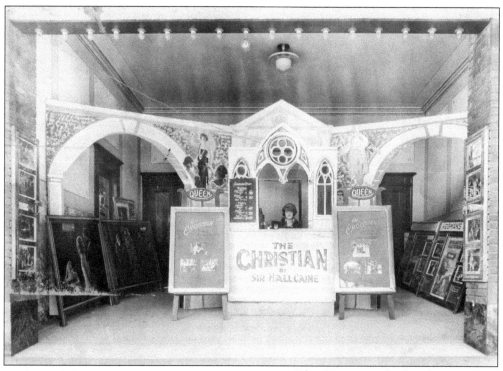

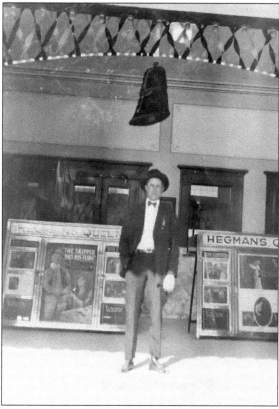

The Queen was the first Austin theater to show movies on Sundays. From 1919 to 1923, Jay J. Hegman battled the courts over the Sunday closing laws—or blue laws, as they were called— which forbade most commerce from occurring on Sundays for religious reasons. Angry that the law turned a blind eye to other businesses operating illegally on Sundays, such as drugstores and confectioners, Hegman openly defied the blue laws by advertising Sunday shows. *The Christian* was advertised in the *Austin Statesman* as opening for an indefinite run starting on Sunday, March 4, 1923. Although a majority of Austinites favored open Sundays, eventually all businesses had to close on Sundays to ensure equal enforcement of the law. John Beckham (left), projectionist for the Queen around 1921, along with Hegman and other theater employees, would routinely get arrested and thrown in jail for working on Sundays, in violation of the blue laws. (Above, AR.2012.009[015]; left, PICA 36774.)

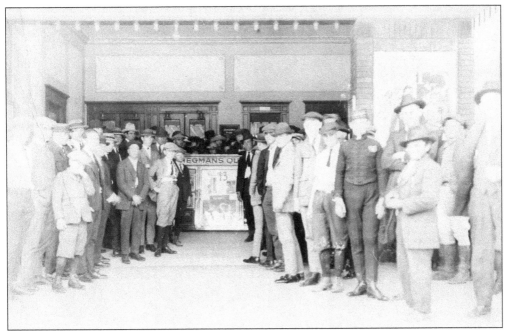

Bell Boy 13 opened at Hegman's Queen on Sunday, March 11, 1923. Pictured here is a theater employee clad as a bell boy along with what is possibly a crowd of theatergoers standing in solidarity in front of the theater waiting to see a show in violation of the Sunday blue laws. (AR.2012.009[014].)

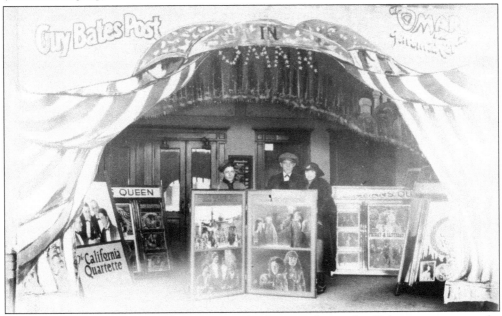

By 1924, Jay J. Hegman had sold his interest in the Queen and moved to Galveston to manage the Grand Opera House. The Queen, Austin's first theater wired for sound, finished the decade on a high note with its screening of *The Jazz Singer*, Hollywood's first feature-length talkie, starring singer Al Jolson. In 1933, the Queen, along with the Paramount and the Capitol, were sold to ITC. (AR.2012.009[022].)

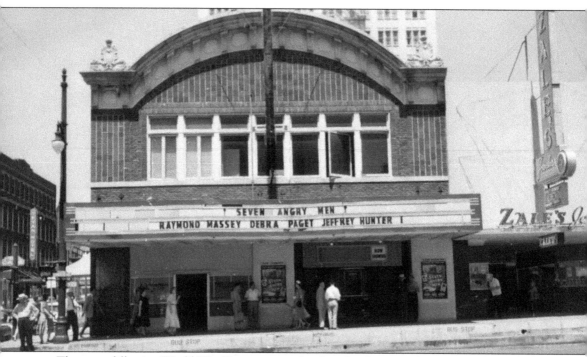

The years following World War II were not so kind to the Queen; it became largely a B-movie house and fell into disrepair. By 1952, it was acquired by former ITC manager Louis Novy's new company, Trans-Texas Theaters Inc. In the summer of that same year, tragedy struck when the ceiling collapsed during a matinee screening of *Tarzan's Savage Fury*. Over 100 children were in the theater at the time. Although no one was seriously injured, several lawsuits resulted. The theater had become more of a liability than an asset. This photograph was taken in 1955, the same year the Queen took her final curtain call. (C00553.)

Three

THE INTERSTATE
THEATER CIRCUIT

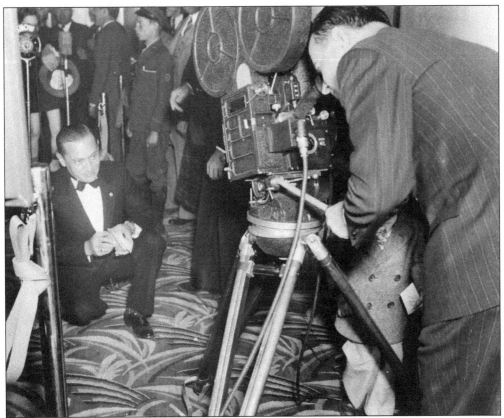

Louis Novy, seen here on the left, was a Russian immigrant who came to Texas in 1912, arriving in Galveston with no money in his pocket and unable to speak English. When Karl Hoblitzelle of Dallas resurrected the Interstate Theater Circuit to manage theaters across the state, Novy, a theater manager in Austin and friend of Hoblitzelle's, was named the manager of ITC's Austin operations. (AR.2012.004[070].)

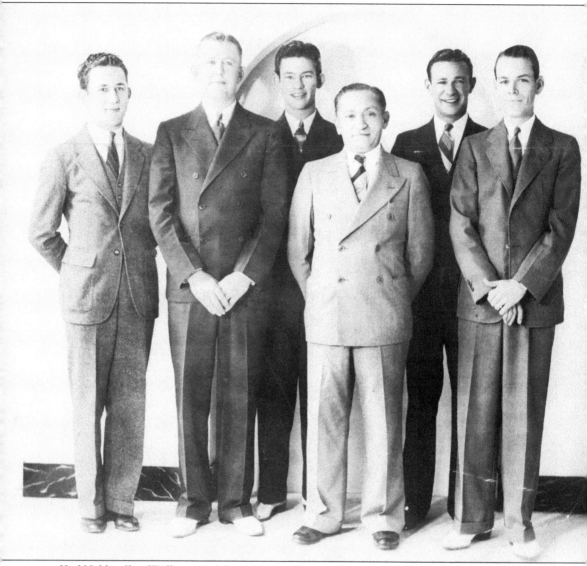

Karl Hoblitzelle of Dallas started the Interstate Theater Circuit in 1905 as the Interstate Amusement Company. Originally, the company managed a vaudeville circuit of performers and theaters. He sold the company in 1930 to RKO Pictures, retaining ownership of some of the theater buildings as a real estate investment. When RKO went into bankruptcy in 1933, Hoblitzelle came out of retirement and took over all of RKO's Texas theater holdings, reorganizing them as the Interstate Theater Circuit. This newly organized company included all the theaters from the old Interstate Amusement Company as well as the Paramount-affiliated Southern Enterprise Theaters. When ITC bought the RKO holdings, it acquired the Paramount, Capitol, and Queen Theaters. This 1935 photograph, taken shortly after ITC moved in, shows, from left to right, Mose Macow, assistant manager of the Hancock; Bill Hellums, manager of the Hancock; Charles Root, assistant manager of the Paramount; Louis Novy, city manager for ITC; Jake Macow, assistant manager of the Queen; and Al Reynolds, manager of the Queen. (AR.2001.018[098].)

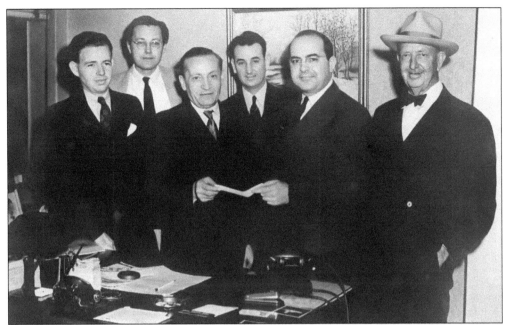

The ITC's motto was "Dedicated to Community Service," and the company lived up to it. In the picture above, Louis Novy is handing a check to Dr. Forrest White for the infantile paralysis fund in 1944. From left to right are Willard Houser of American Bank, Elmo Hegman of the Ritz Theater, Novy, Frank Luchesse of the Harlem Theater, White, and R.S. "Skinny" Pryor of the Cactus Theater. Novy and ITC also participated in the annual March of Dimes fundraisers, as seen below. Novy was the chair of the fund drive in 1947, and here, he watches as actress June Lockhart points out the fundraiser box. Charles Sandahl, the executive chair of the fund drive, and Frank Starz of ITC also look on. (Above, PICA 38438; below, AR.2012.004[072]).

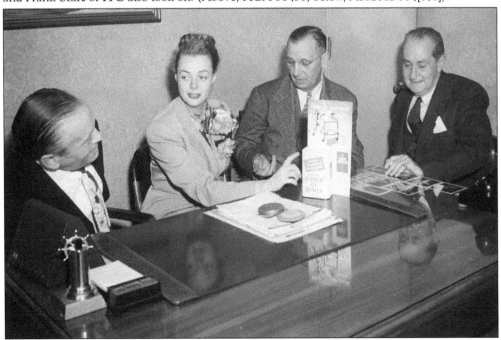

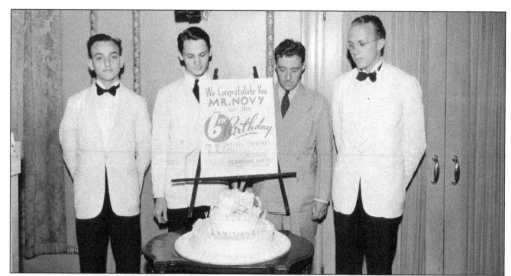

The ITC was not above a little lightheartedness in the midst of its community service. It had special events at its theaters on its "birthday," such as the celebration (above) of its sixth birthday on July 18, 1939. The ITC also entertained some Hollywood stars, such as the national tour of the "Petty Girls" in 1950. Novy can be seen below greeting the four "Petty Calendar Girls" on the nationwide tour for the premiere of the movie *The Petty Girl*, opening at the Paramount on October 3, 1950. The film chronicled the life of artist George Petty, known for his airbrush images of the female form that led to the proliferation of pin-up beauties. (Above, C06060; below, AR.2012.004[173].)

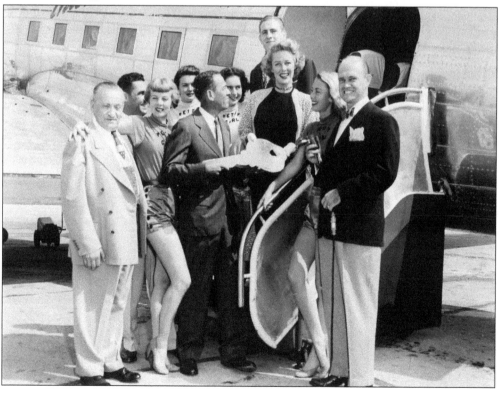

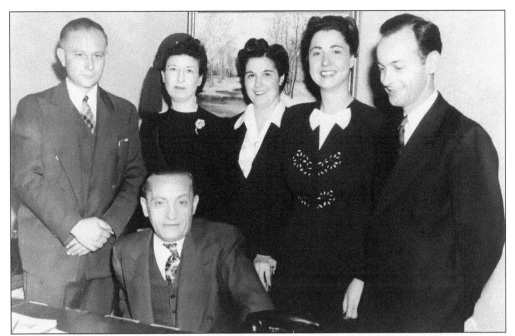

With men off fighting in World War II, opportunities for women to manage theaters arose. Novy named three women managers shortly after the war started: Elizabeth Fletcher (Varsity), Gladys Roe (Texas), and Pearl Hellums (Austin). Roe is second from left in this picture; it is unclear which of the other two women are Fletcher and Hellums. (PICA 30147.)

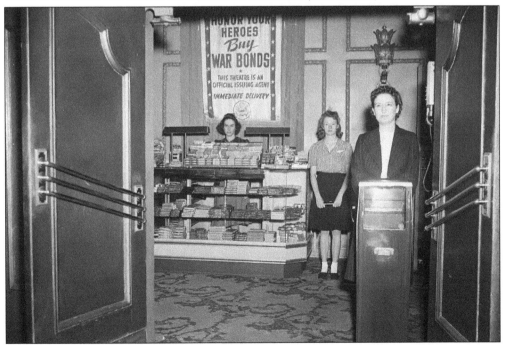

The ITC also participated in the war bond effort during World War II. Novy won multiple awards for his efforts to have the Austin theaters support the war and sell war bonds. Moviegoers could pick up their bonds, along with their popcorn and candy, at the concession stand. (AR.2014.035[661].)

When ITC first moved into Austin, the company concerned itself with operating the existing theaters. The flagship theater for the chain was the Paramount. The early 1940s image below shows the Paramount ticket booth, one of the changes to the front of the building as a result of the 1930s renovations. Formally dressed ushers helped create an enjoyable movie-going experience. Many young men in the theater business, including local theater managers Charles Root and Bill Hellums, got their start as ushers. (Left, C06824; below, AR.2001.018[005].)

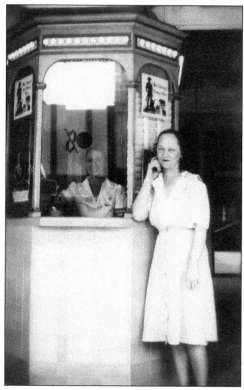

The ITC employed many Austinites in its operations, with the Paramount the biggest employer as the flagship theater. These 1945 images show a few of the many employed by ITC. The picture at right shows a number of female employees, ticket agents, and concessionaires. From left to right are (first row) Mary Louise Royce, Winfred Heff, and unidentified; (second row) three unidentified; (third row) Jeannette Joseph Burkett, Betty Lou McCoy, and two unidentified; (fourth row) Margaret (Godfrey) Vick. Pictured below from left to right are (first row) Louis Novy, Homer Duffie, and William C. Hopkins; (second row) projectionists Sam Duffie and Euel P. Ischy, and unidentified (Right, C09684; below, C09865.)

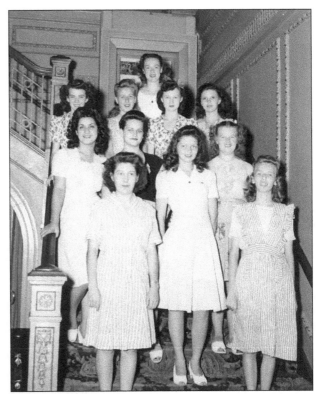

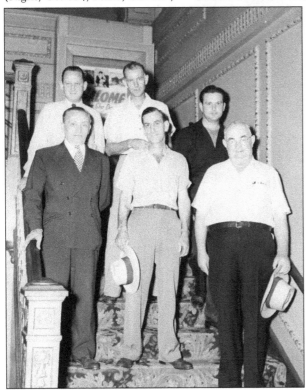

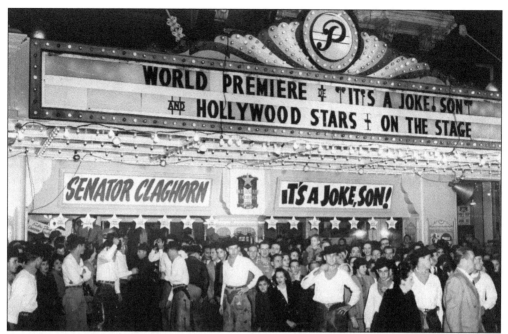

The Paramount played host to numerous world premieres during its time as an ITC theater. Kenny Delmar's *It's a Joke, Son!* premiered on January 21, 1947, as pictured above, with Delmar, June Lockhart, and Una Merkle headlining the live cast appearance. The movie is based on the character Sen. Beauregard Claghorn created by Delmar. Below, Sonny and Cher make an Austin appearance for the premiere of their film *Good Times* on April 11, 1967. In addition to appearing on stage after the movie, the pair participated in a parade down Congress Avenue, christened "Sonny & Cher Avenue" for the day. (Above, AR.2012.004[073]; below, AR.1997.012[764]).

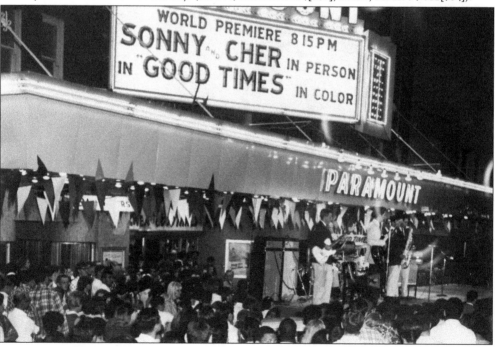

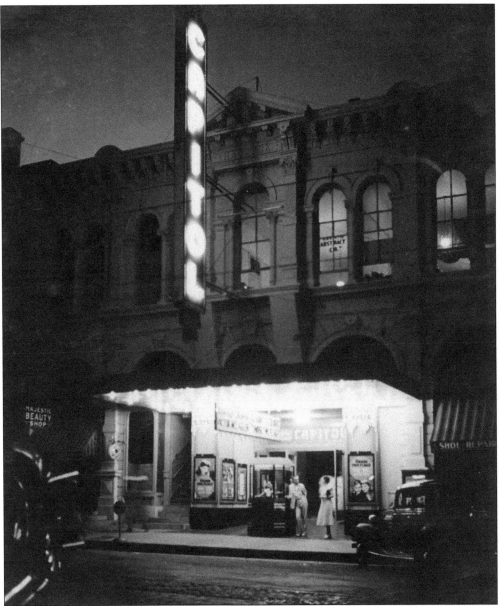

The ITC took over operations of the Hancock Theater on West Sixth Street, renovated the building, and reopened it as the Capitol Theater in 1934 (shown here in 1936). For most of its life as the Capitol, the theater was a second run theater, and by the time the Trans-Texas Theater Company took over the Capitol in the 1950s, it was showing mostly burlesque and adult films. It closed on December 31, 1963, when Trans-Texas announced just before the final show that it was not renewing its lease on the building. The Texas Fine Arts Association hoped to restore the building to its original grandeur and reopen it as the Hancock Opera House, but they were unsuccessful. (PICA 32940.)

Bill Hellums, shown here standing behind the concession stand in the Capitol, was a longtime ITC employee and manager of the Capitol Theater. (PICB 17105.)

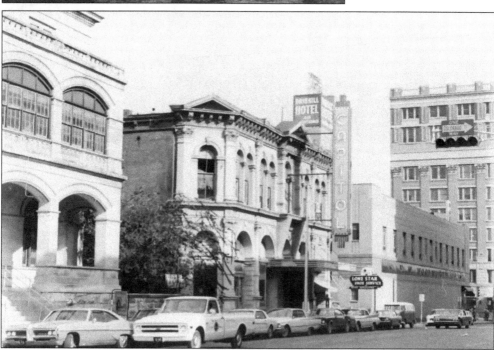

This photograph by Nolen Williamson shows the Capitol Theater after it closed but before it was lost to history to become a parking lot. (PICA 01754.)

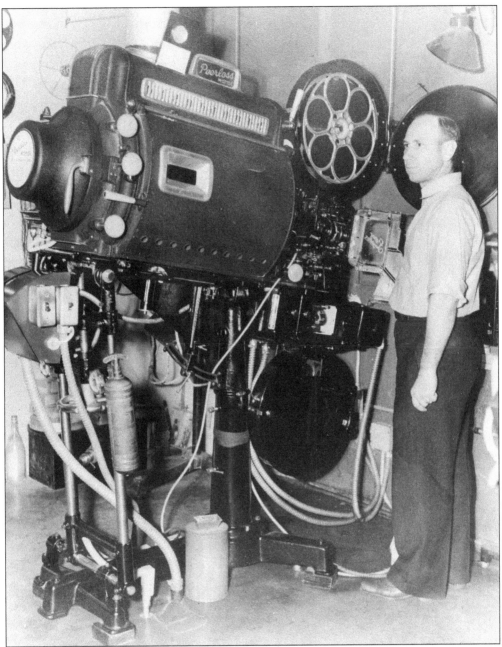

John W. Carpenter was a longtime projectionist working in Austin; he was working at the Capitol when the ITC took over the theater. He is shown here in the Capitol projection booth in the early 1930s. He gave this picture to his union, the IATSE (which he joined in 1912). Jim Maloy, a longtime IATSE member and Austin projectionist, donated copies of this and other early photographs to the Austin History Center, helping preserve movie theater history and making this book possible. (PICA 36777.)

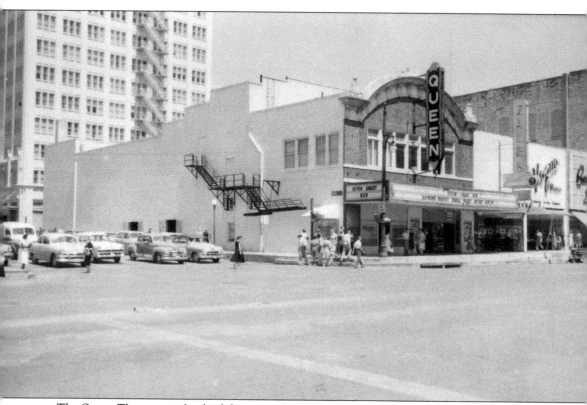

The Queen Theater was the third theater in the ITC inventory when it began operations in Austin. With the flagship Paramount across the street, the ITC exhibited mostly second-run films at the Queen before selling the theater to the Trans-Texas Theater Company in the 1950s. (C00555.)

Just a couple years after moving into Austin, ITC built its first new theater in town, the State Theater. The image at right from the Paramount Theater Records shows the theater shortly after it opened next to the Paramount but before it expanded into the retail space that divided the two theaters. The blade, marquee, and especially, the lobby show the Art Deco design from architect W. Scott Dunne. *The Bride Comes Home* starring Fred MacMurray and Claudette Colbert was the opening movie. (Right, AR.2001.018[001]; below, PICA 23290.)

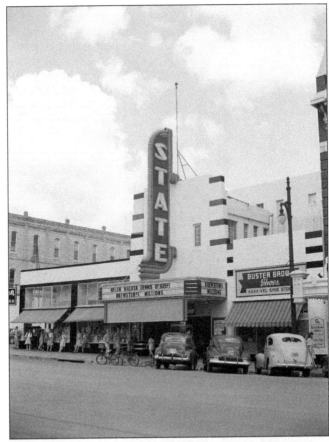

In the 1970s, the State fell on hard times and exhibited mainly B movies and adult films. Attempts were made in the 1980s and 1990s to revive the theater, including a brief run as a live theater venue under the auspices of the Live Oak Theater Company. It is now owned by the Paramount Theater and runs as the Stateside at the Paramount. (PICA 38156.)

The State often played second fiddle to its older sibling next door, such as in this scene of the world premiere of *The Fabulous Texan* in 1947. (PICA 12727.)

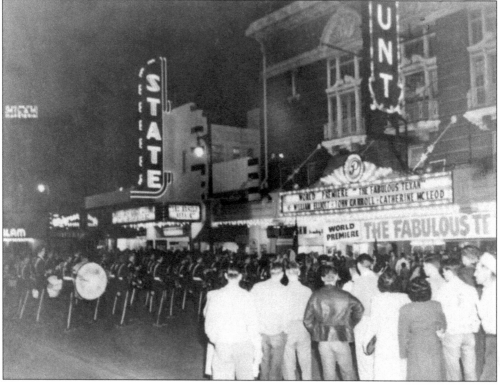

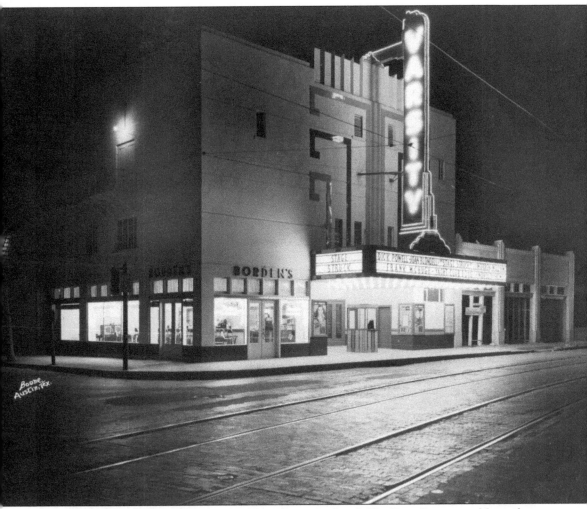

The ITC built the Varsity Theater in 1936, and it opened with *The Texas Rangers* on November 20, 1936. The film was directed by King Vidor and was based on Walter Prescott Webb's book of the same name. Gov. James Allred had a cameo appearance and served as a guest director, by telephone, for one scene. He was the guest of honor at the premiere. The Varsity was designed solely as a movie house with no other intended use and was meant to be a neighborhood theater. (PICA 06734.)

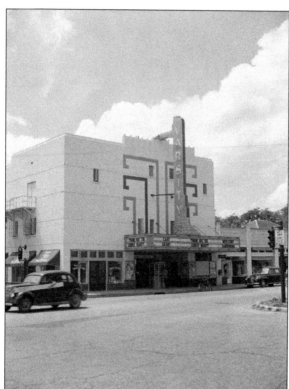

The Varsity was one of three ITC theaters to show *None But the Lonely Heart* starring Cary Grant in 1945. Early in its life, it showed first run films, sometimes after the bigger downtown theaters ran them. (AR.2001.018[002].)

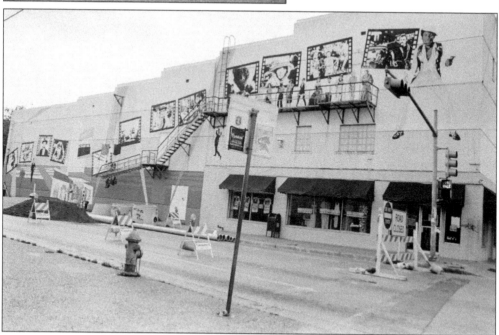

In 1979, local artist Carlos Lowry painted the iconic mural that still graces the south wall of the theater, at least in part. The mural was repainted and moved higher up the wall in 2011 when the building owners remodeled the space for its restaurant tenants. (Photograph by Grace McEvoy, PICA 24700.)

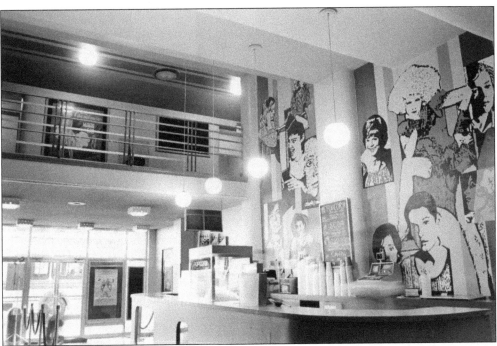

The Varsity featured Art Deco frosted-glass doors and an octagonal box office in front. A colorful Deco mural by James Gilboe once graced the lobby but is now gone. The image above shows the front lobby and concession stand. Below are the stairs to the balcony, with the Deco stylings clearly evident. Both pictures were taken on May 17, 1990, shortly before the theater closed. (Above, photograph by Grace McEvoy, PICA 24704; below, photograph by Grace McEvoy, PICA 24705.)

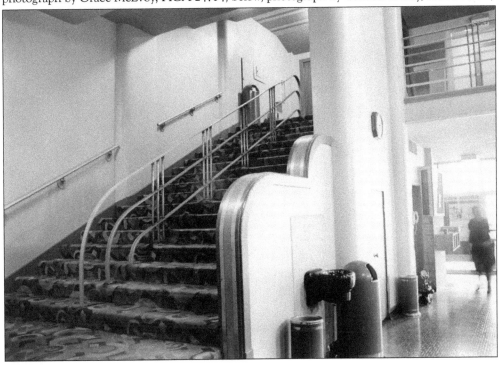

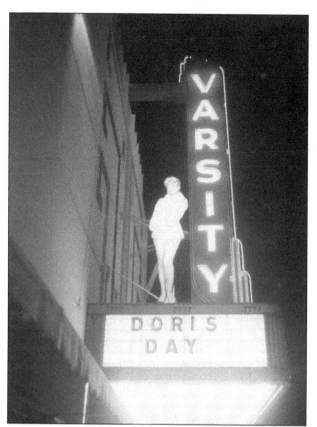

In 1957, the Varsity ran the then-new Doris Day film *Pajama Game*. As a publicity stunt, they posted a 15-foot-high photograph on the marquee. Before the image was installed, someone stole it from the lobby (The *Austin Statesman* headline read, "Doris Day kidnapped from the Varsity!"), but she was returned and took her place on the marquee. (PICA 36853.)

In 1977, as the multiplexes took over, the Varsity became an art film house owned by John Bernardoni. A second balcony screen was added, and the theater featured art films, nostalgia films, and some second-run films. By 1980, it was showing first run art films exclusively and closed 10 years later, on May 17, 1990. Steve Wilson, the last manager, is second from the right, and his assistant manager David Ray is second from the left. (Photograph by Grace McEvoy, PICA 24721.)

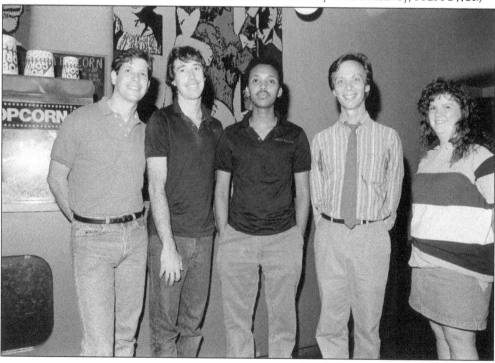

Though not a new theater, the Texas Theater joined the ITC chain sometime in the late 1930s. It was just a few blocks away from the Varsity, giving the ITC two neighborhood theaters in the University of Texas neighborhood. (AF-M8300(13)-001.)

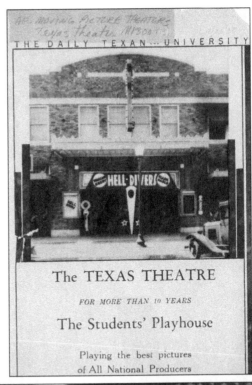

THE DAILY TEXAN...UNIVERSITY

The TEXAS THEATRE

FOR MORE THAN 10 YEARS

The Students' Playhouse

Playing the best pictures
of All National Producers

The Texas Theater showed mostly second-run films and the occasional foreign film. By the 1950s, it became mostly an art film theater known for its fall film festivals. This picture was taken in October 1956 when the cinematic version of Puccini's *Madame Butterfly* came to Austin. (PICA 36766.)

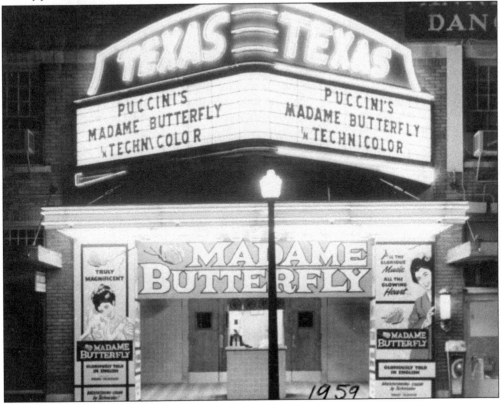

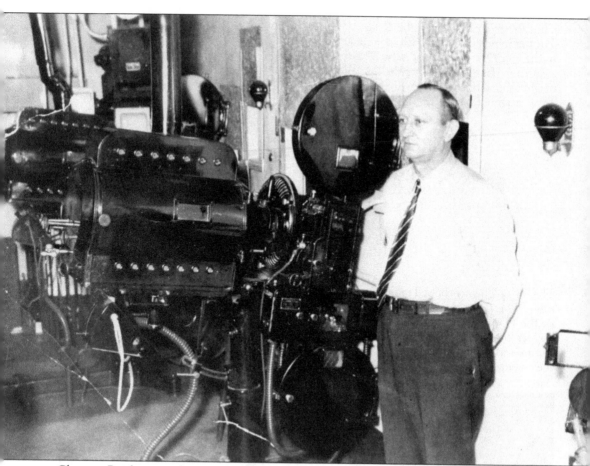

Clarence Rowley was a longtime projectionist working in Austin theaters, including the Texas. Projectionists did not always get to watch the films they showed, having to focus instead on the film quality and mechanics. According to a 1972 interview Rowley gave, missing the movie was not always a bad thing. (PICA 36765.)

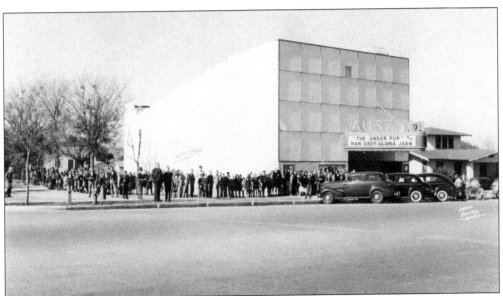

The Austin Theater, built by the ITC, opened on August 18, 1939, showing *Stanley & Livingston*. This was truly a "suburban" movie house, with its location on Live Oak Street, near Oltorf Street, then the southern boundary of the city. The land was a former cow pasture owned by the Long family, proprietors of Long's Vacuum Service, which is still open next door. It was the first theater in Austin to offer "staggered" seating to afford maximum views for customers. It had a maroon color scheme and included large lobby mirrors, expensive carpet, and wall murals painted by Eugene Gilbow. Unfortunately, the murals were covered by wainscoting in 1978. (Above, C07084; below, PICA 36767.)

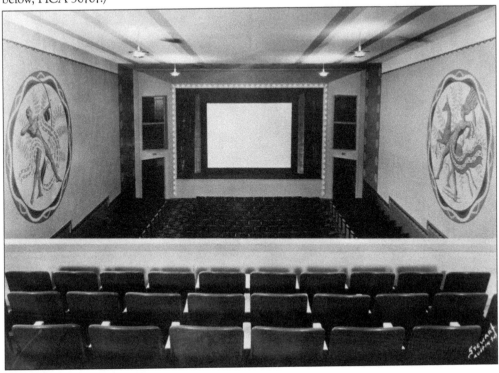

Neighborhood theaters like the Austin also played host to community events, such as lectures, garden club meetings, and more. This group of expectant-looking children was at the theater perhaps attending one of the weekly McNamara Birthday Club events. This was a birthday party for kids under 16, with free admission for kids during their birthday week and a cake, all sponsored by McNamara Bakery. They held similar parties at the Capitol Theater for kids who lived north of the river. (C07085.)

65

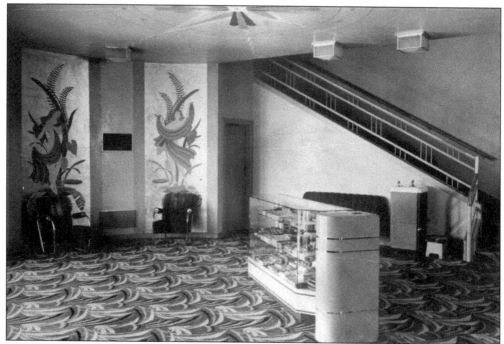

This view of the Austin Theater lobby, taken a couple months before the theater opened to the public, shows it as, according to the South Austin Civic Club, "a theater that is modern in every way. We have installed the latest motion picture equipment and we are sure the patrons will find the theater comfortable and an asset to the community." (PICA 36769.)

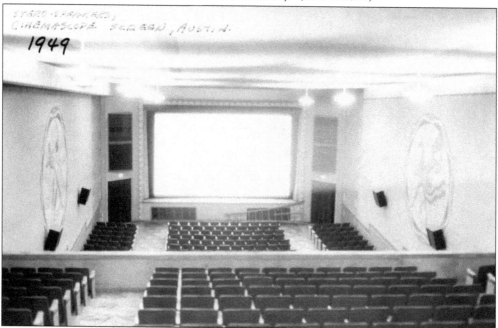

Not too long after it opened, the Austin underwent renovations. In 1949, the ITC installed a new Cinemascope Screen and stereo speakers to enhance the movie-going experience. (PICA 36770.)

66

John Beckham, pictured below in front of the theater, was one of the first hires for the new Austin Theater in 1939. Francis Vickers, an "energetic young man" of 21, was named the first manager, being promoted from assistant manager of the Capitol Theater. Vickers hired South Austin residents Frances Blanton and Cecil McArthur to fill out his staff. Most of these theater positions were transitory, with students often taking the concession and usher positions. Projectionists belonged to the local union and often moved from theater to theater. Jim Maloy, pictured at right in the Austin Theater projection booth in 1948, replaced Beckham as one of the projectionists. (Right, PICA 36820; below, PICA 36768.)

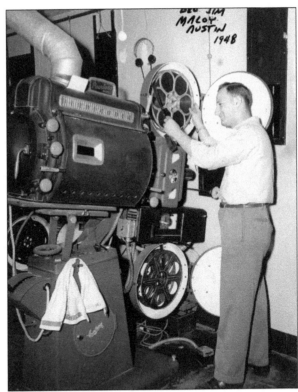

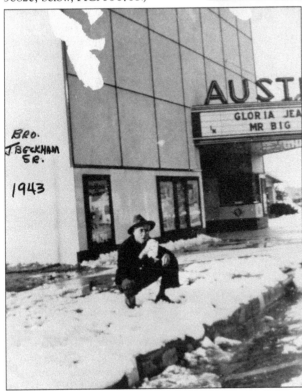

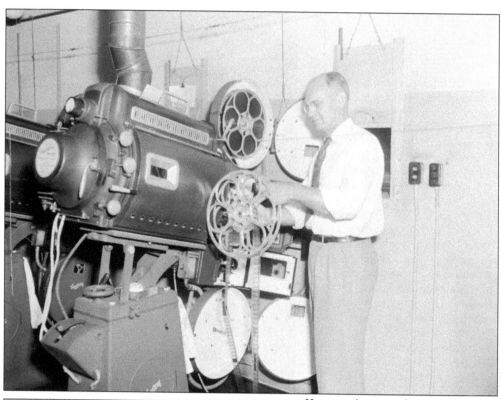

Keeping the open-door rotation of projectionists, Gilly Ballenstadt joined the staff at the Austin. He is pictured here working the booth on October 11, 1950. (ND-50-A007-01.)

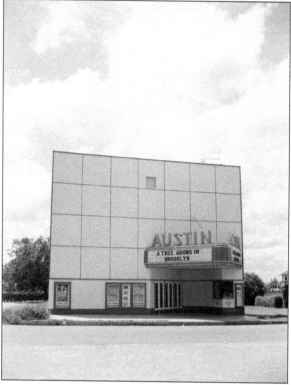

By the 1950s, the Austin became a second-run theater. In the early 1970s, Ascarte Company took over management and exhibited Spanish language films. In June 1977, it became Cinema West, showing adult films. It was one of the last pornographic theaters to close in Austin, showing its final film on October 31, 1998, and has been home to a series of businesses, with adlucent taking over in 2011. (AR.2001.018(004).)

Four

TRANS-TEXAS THEATERS INC.

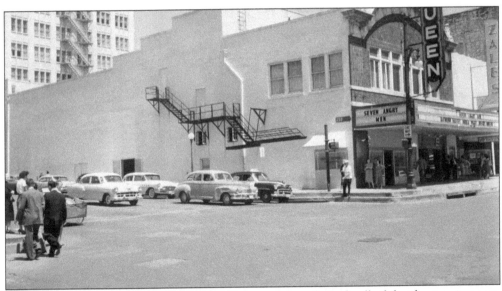

By the mid-1940s, the Interstate Theater Company owned nearly all of the theaters in town. This monopoly came to an end in 1948 when the US Supreme Court ruled that studios could no longer own movie theaters to control the distribution and exhibition of their films. To be in compliance, the Paramount-affiliated ITC sold the Queen (pictured here in the 1950s) and Texas Theaters to the newly formed Trans-Texas Theater Company in 1952. (C00556.)

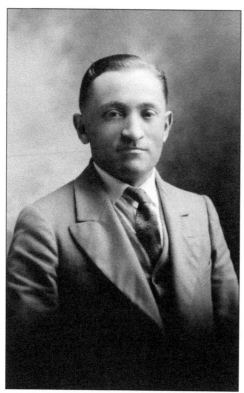

Louis Novy, former ITC manager for its Austin-based operations, formed Trans-Texas in partnership with his son Harold (nicknamed "Buster"), daughter Lena, and her husband, Earl Podolnick. Born Leiser Nowordworski in Bialystok, Russia (now Poland), Novy arrived in Galveston in 1912 penniless and unable to speak English. He eventually moved to Austin in 1917, and by 1919, had become the manager of the Hancock Opera House (later called the Capitol Theater). Novy died in Austin in August 1958. Below, he is pictured with his daughter Lena and son-in-law Earl sometime in the 1950s. Earl served as the company's first vice president. Initially, the company owned 22 theaters across Texas, including Austin, El Paso, Wichita Falls, and Fort Worth. Earl took over as president following the death of Harold in 1960. Earl and Lena were known for working very closely as a team. Together, they reorganized the company, eliminated 12 theaters from its holdings, and renovated its remaining theaters. The company was sold to American Multi-Cinema Inc. (AMC) in 1979. (Left, AR.2012.004[069]; below, AR.2012.004[193].)

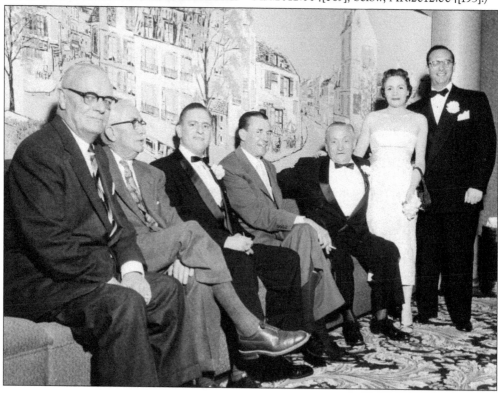

In 1953, Trans-Texas acquired the Capitol Theater. By the time Trans-Texas took over, the theater was showing mostly burlesque and adult films. It closed on December 31, 1963, with its last show being *Girls A-Poppin*. The theater was razed to put in a parking lot sometime around the time this photograph was taken in the late 1960s. (PICA 36787.)

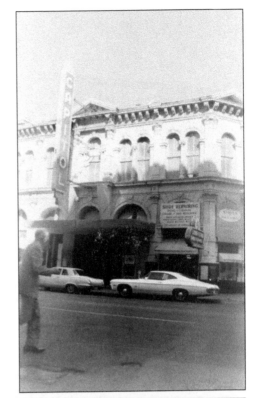

Other early Trans-Texas acquisitions included two of Austin's most beloved drive-in theaters, the Burnet (shown here in 1954) and the Chief. Both drive-ins were designed by Frank Lopez and originally owned by Charles Ezell & Associates. Trans-Texas owned and operated both drive-ins until they closed in the 1970s. (ND-54-494-04.)

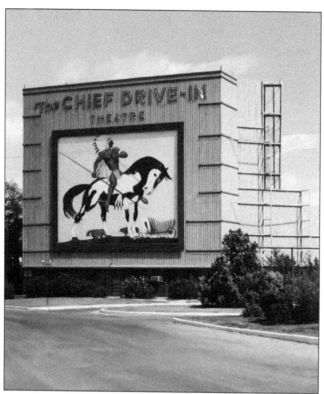

In July 1964, the Podolnicks celebrated the Chief's 17th anniversary by giving it a major facelift. Improvements included an air-conditioned snack bar (the only air-conditioned drive-in concession area in the state), a color TV room, restrooms, a new marquee, and a new train station for the much beloved kiddie train "Lil Toot." The screen and screen tower were given fresh coats of paint as well as the prominent signage in back of the screen, which featured a feathered Indian astride a spotted pony. Pictured below cutting the ribbon during the grand-reopening ceremony of the modernized Chief are, from left to right, Blossom, Jay, and Marina Podolnick. Earl and Lena Podolnick look on behind Jay. (Left, AR.2012.004[061]; below, AR.2012.004[152].)

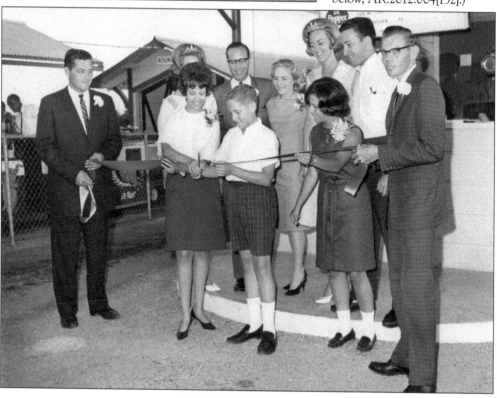

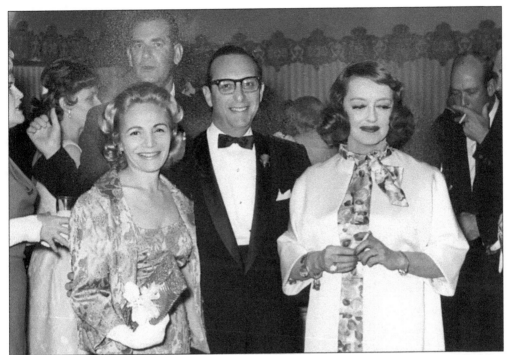

In 1964, Earl Podolnick was singled out among over 400 drive-in theater owners to win the John H. Hardin Award for achievements as a drive-in theater exhibitor. Presentation of the award was made at the Texas Drive-In Theater Owners Association held in Dallas in February 1965. In attendance at the event were celebrities such as Bette Davis (pictured above with Lena and Earl) along with Olivia De Havilland, Joan Holliday, and Hope Freeman, both featured in *The Rounders*, which just so happened to be the opening feature for the Podolnick's new Americana Theater (see page 74). Below, around the same time, Earl Podolnick got to meet another movie icon—Walt Disney—at the Motion Picture Merchandising Convention. The other two men are unidentified. (Above, AR.2012.004[090]; below, AR.2012.004[085].)

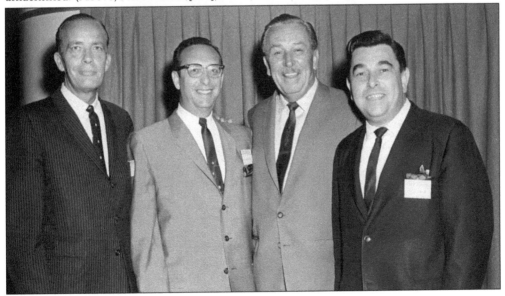

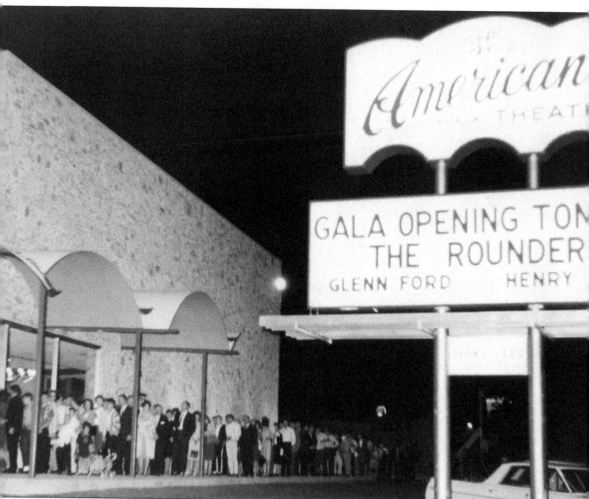

Austin saw its first new movie theater in nearly 30 years when Trans-Texas built the Americana. The grand opening was held on April 28, 1965, with the Hollywood premiere opening of the lighthearted Western comedy *The Rounders*, starring Glenn Ford and Henry Fonda. Hundreds of Austinites turned out for the event. Designed by architect Bill Saunders, the 783-seat theater was the first new construction for the Trans-Texas Theater chain in Austin. In his weekly newspaper column for the *Austin American-Statesman*, local journalist and broadcaster Richard "Cactus" Pryor (son of Cactus Theater owner Richard "Skinny" Pryor and namesake of the theater) proclaimed the Americana to be "what a motion picture theater should be . . . something special." (AR.2012.004[005].)

The premiere was quite the extravaganza, complete with Hollywood-style flood lights, live television coverage, and in-person appearances by director Burt Kennedy and producer Richard E. Lyons. *The Rounders* director Kennedy (pictured) was first in line to buy a ticket to the premiere. (AR.2012.004[011].)

It was also a family affair. A joyful Lena Podolnick (center, in white dress) along with husband Earl (holding scissors) cut the ribbon at the opening ceremony for the Americana. Daughters Marina and Blossom are second and third from the left, and son Jay is at far right. The others are unidentified. (AR.2012.004[198].)

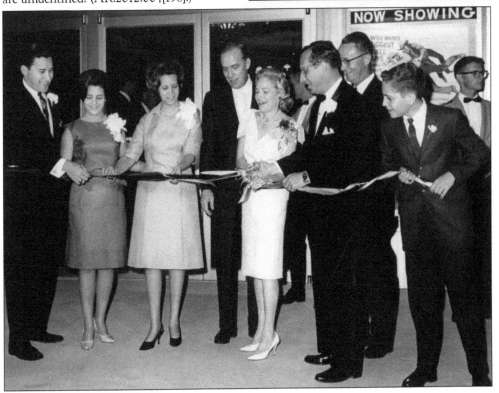

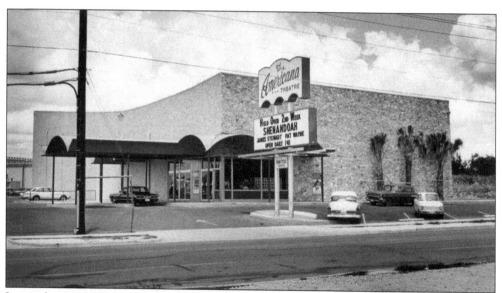

Located at 2200 Hancock Avenue in the quiet, family-oriented north central neighborhood of Allandale, the Americana was designed with the suburban moviegoer in mind. It offered drive-through parking under a canopy to enable cars to conveniently drop off passengers in the front of the building while the driver parked in one of the numerous spaces surrounding the building. The theater was touted in the *Austin American-Statesman* as "Austin's newest and magnificently luxurious showcase" and boasted modern features such as an inside box office for convenience and protection from the Texas elements. The Trans-Texas home office was located right across the street from the theater. Shortly after its grand opening, the Americana was selected as the site for the state premiere of Columbia's *Cat Ballou* starring Jane Fonda and Nat King Cole. This appearance was the last for singer Nat Cole, who was sick with lung cancer during the shooting of the film. Below, the premiere featured a community square dance similar to the square dance scene featured in the movie. (Above, AR.2012.004[197]; below, AR.2012.004[003].)

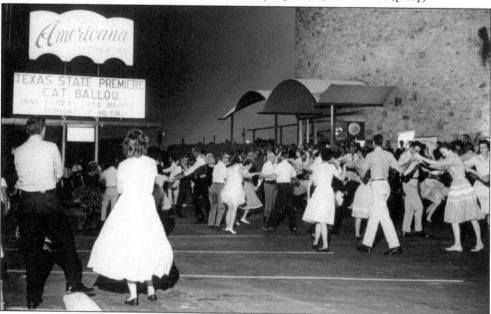

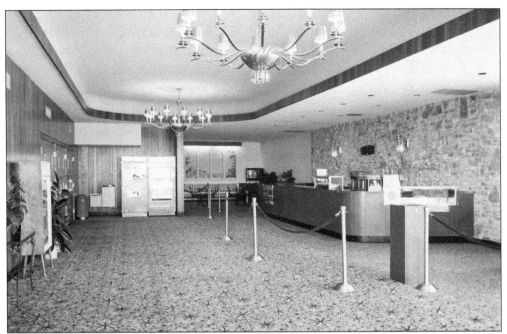

The Americana's lobby had funky, Mid-century Modern design features including brass wall fixtures, wood paneling, a star-studded carpet pattern, and vending machines for soda and cigarettes. A candy machine is located at far left, next to the auditorium doors. To the back of the lobby is the innovative television waiting lounge. (AR.2012.004[014].)

This is another shot of the lobby with the auditorium doors open. Looking through the doors on the left, the red sign indicates that smoking is permitted inside the auditorium. The Podolnicks incorporated many of the same Mid-century design features for the Southwood, their second new theater construction in Austin (discussed later in this chapter), including the carpeting and the color-blocked wall pattern visible here inside the auditorium entrance. (AR.2012.004[012].)

The Americana boasted an innovative television lounge, complete with the latest color television set for customers waiting for features to begin. Those uninterested in watching television could rest their eyes on a large, tropically-inspired seascape that filled the back wall. The stairs at left led up to the luxurious ladies' lounge on the second floor. (AR.2012.004[002].)

The ladies' lounge featured plush carpeting, fancy Queen Anne–inspired cushioned seats ,and a well-lit vanity area fit for movie stars preparing for their close-ups. No expense was spared in creating a space where customers—in this case, women—could feel comfortable and pampered. (AR.2012.004[004].)

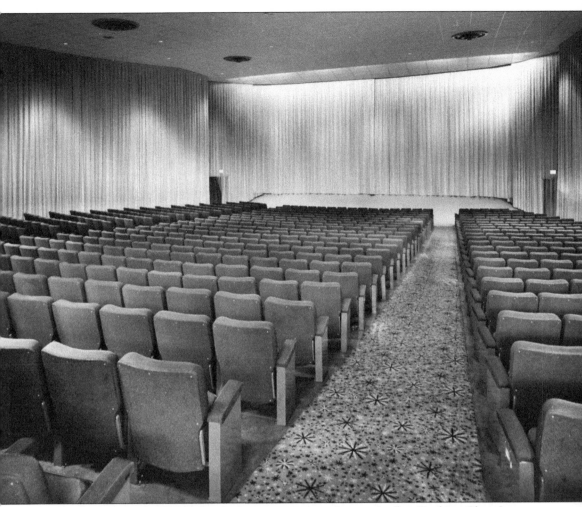

The Americana was the first and only theater in town to feature Airflow Rocking Chair Loge seats, which, according to the press material, gently rocked back and forth to "melt patron's tensions away as they were delightfully entertained." The theater was equipped with state-of-the-art 70 and 35 mm film projection equipment as well as six-channel stereophonic sound. The auditorium was completely draped and housed a very large, slightly curved single screen designed to diffuse light in order to make the most of the latest motion picture processes available. Smoking was allowed throughout the building, including the auditorium. Unable to compete with the multiplexes, the single-screened Americana closed its doors on April 5, 1987. At the time, it was the last single-screen neighborhood theater left in town. (AR.2012.002[015].)

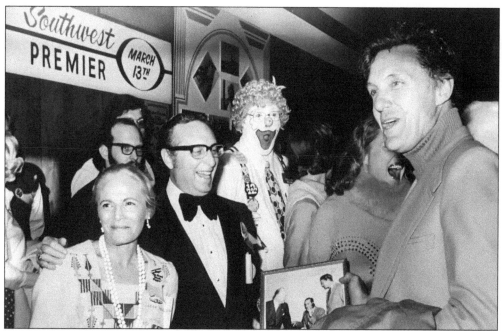

Earl and Lena Podolnick are pictured above at the special screening of *The Great Waldo Pepper* starring Robert Redford at the Americana Theater on March 13, 1975. The special showing was a benefit for the Town Lake Beautification Project. Stars Robert Stack, shown here, and Peter Graves, not pictured, kicked off the event. Above, Stack is holding Earl Podolnick's personally autographed photograph (below) of, from left to right, Nigel Bruce, Basil Rathbone, and a much younger Robert Stack. In 1942, the three Hollywood stars participated in the Stars over America war bond campaign, which had multiple stops in Texas. They ended their Texas tour on September 20 with a war bonds luncheon held at the Stephen F. Austin hotel and an evening rally at the University of Texas's Gregory Gym. They were greeted in front of the hotel by Louis Novy, Earl's father-in-law and chairman for Austin's participation in the campaign. (Above, AR.2012.004[088]; below, AR.2012.004[089].)

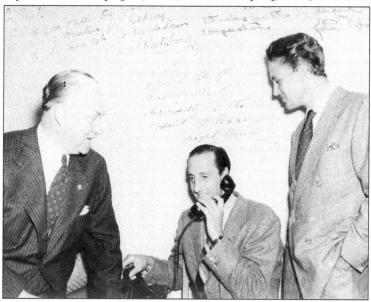

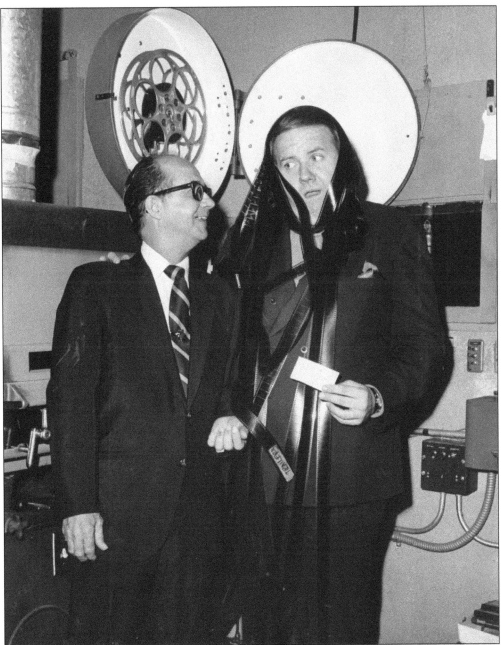

In 1966, Trans-Texas gave another one of its early acquisitions, the Texas Theater, an extensive makeover. The Texas, which served primarily the University of Texas at Austin community, received modern upgrades such as air conditioning and a new concessions area. In this photograph, actor and comedian Chuck McCann (right) clowns around with local projectionist John Beckham. McCann was visiting Austin in March 1971 to promote his new film *The Projectionist*, which opened at the Texas on March 24, 1971. The film is about a projectionist who fantasizes about being one of the superheroes in the movies he shows. It also marked the screen debut of comedian Rodney Dangerfield. McCann was made an honorary projectionist in the IATSE Local No. 205 and is shown here holding his new membership card. (PICA 36778.)

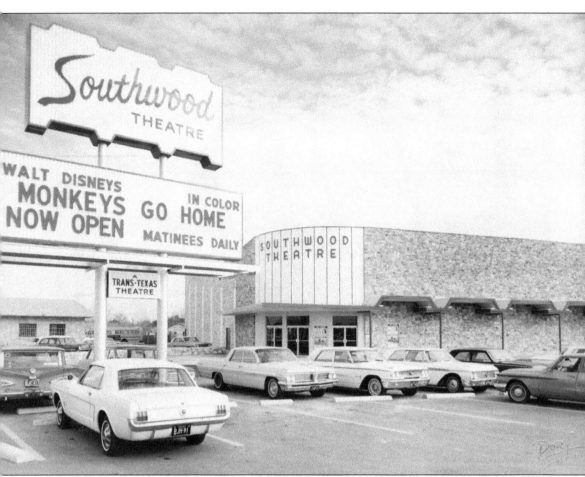

The Southwood Theater opened on February 17, 1967, in the newly built Southwood Shopping Center on Ben White Boulevard. The new, first-run theater boasted 1,000 seats. It was the first indoor theater built in south Austin in nearly 30 years and only the second indoor theater located on the city's south side. The opening movie was the comedy *Monkeys, Go Home!* starring Maurice Chevalier, Dean Jones, and Yvette Mimieux. (AR.2012.004[208].)

Ben White, Austin city councilman from 1951 to 1967 and for whom Ben White Boulevard was named, is shown here standing between Earl and Lena Podolnick at the ribbon-cutting ceremony for the Southwood. From left to right are (first row), unidentified, Earl Podolnick, Ben White, Lena Podolnick, and Jay Podolnick; (second row) two unidentified men and Bob Bru, manager for the Southwood. (AR.2012.004[209].)

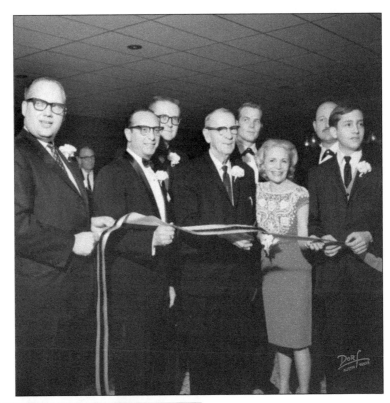

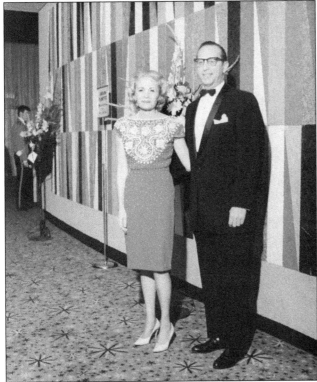

Earl and Lena Podolnick pose in the lobby of the Southwood Theater on opening night. Designed by Leon Chandler, the Southwood was similar in design to the Americana, including interior features such as the color-blocked wall pattern and star-studded carpeting. (AR.2012.004[006].)

The candy counter at the Southwood boasted the latest in confections and equipment. It also looked very similar to the Americana's down to its stone backsplash, wall clock, and surrounding floor. It was positioned by the entrance, next to the ticket booth, just like the one in the Americana. The only discernible difference between the two theaters' concession areas, judging from photographs, was the matching coach lights hanging on the concession stand wall. (AR.2012.004[205].)

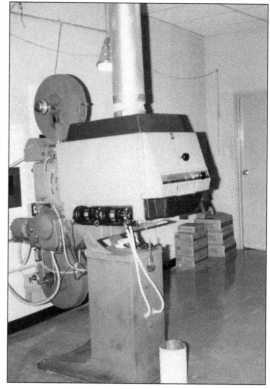

Here is a 35 mm film projector inside the projection booth of the Southward around 1977. The projectionist had automated stage curtain controls that allowed switching to accommodate different screen projection sizes. There was also a stage in front of the screen to accommodate live performances. In the 1970s, the single-screen Southwood was "twinned"—converted to a double-screen theater—in order to compete with the growing number of multiplexes in town. (PICA 36850.)

The ticket counter at the Southwood, pictured to the right, was located inside the theater between the entrance and the concessions counter. The interior of the lobby, including the back wall of the ticket counter, was paneled in walnut. The waiting lounge outside the restrooms, pictured below, felt more like a living room than a waiting area, with its plush wall-to-wall carpeting, his-and-her couches, an assortment of fine art paintings, and fancy chandeliers, which matched the concession counter coach lights mentioned earlier. Again, as can be seen from the strategically placed ashtrays standing between the couches, smokers were made to feel right at home. (Right, AR.2012.004[206]; below, AR.2012.004[001].)

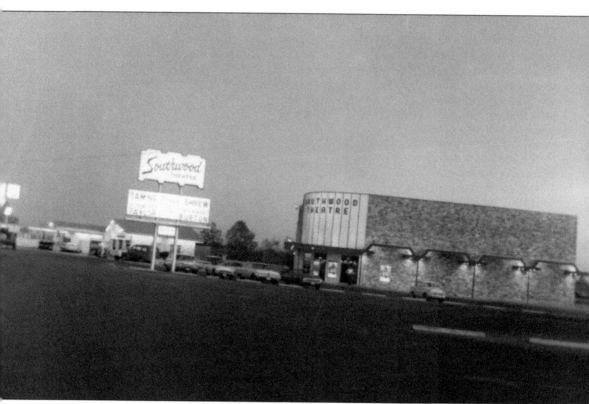

Although not apparent from this 1967 photograph of the Southwood taken at night, the exterior lights surrounding the building were red, green, and blue, and the exterior walls were composed of 12-inch square ceramic tiles. Presidio Theaters took over the theater in 1989; it closed in 1996. (PICA 36852.)

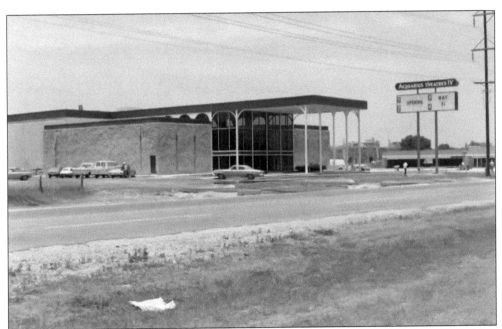

Trans-Texas opened the Aquarius IV, Austin's first four-plex theater, on May 31, 1973, at 1500 Pleasant Valley Road in southeast Austin. The theater included four separate theaters under a single roof—two 250-seat theaters, a 500-seat theater, and a 700-seat theater for a total combined seating capacity of 1,700 seats. Like the Americana, the theater had a large porte-cochere, or covered entrance, that allowed vehicles to drop off passengers in front. Customers could purchase tickets for any one of the four theaters at an inside box office. The opening films were *Fiddler on the Roof, Slither, The Legend of Boggy Creek*, and *Ace Eli and Rodger of the Skies*. (Above, AR.2012.004[144]; below, AR.2012.004[054].)

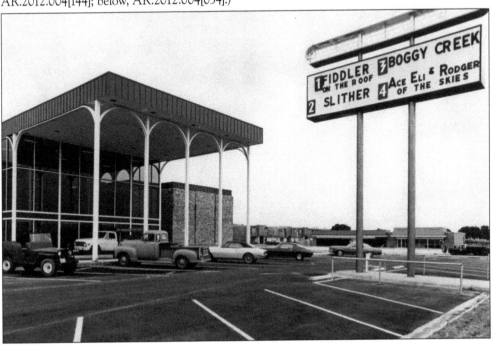

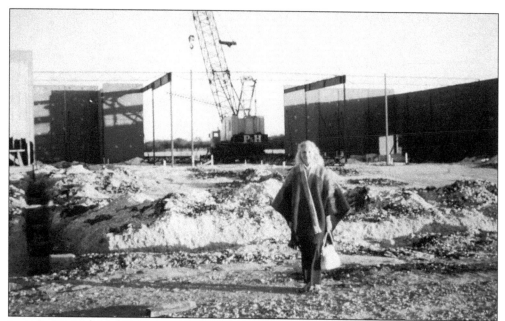

Lena Podolnick is pictured here standing at the four-acre construction site of the Aquarius IV. The four-plex theater was introduced in 1971 as a "revolutionary concept in motion picture exhibition" by the *Austin American-Statesman*, a full two years before its grand opening. The southeast Austin location was chosen because of the "tremendous growth" at the time along East Riverside Drive and its accessibility to the Interstate 35 freeway. (AR.2012.004[060].)

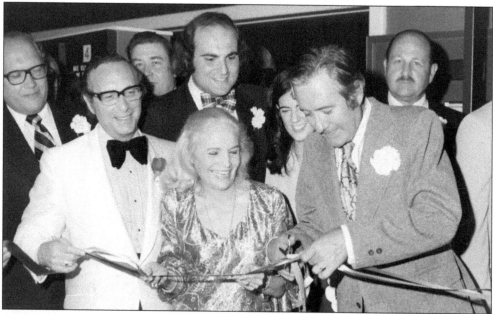

At the ribbon-cutting ceremony for the Aquarius IV, Earl and Lena hold the ribbon while Austin city councilman Dan Love does the cutting. Standing in the back, Trans-Texas's Dick Empey (left) and Councilman Jeff Friedman look on. Bob Bru (standing behind Dan Love, facing camera), manager of the Southwood, was named manager of the new Aquarius IV. Some 500 guests attended the opening. (AR.2012.004(030).)

The Aquarius IV in Austin was modeled after the Podolnicks' Aquarius IV in Dallas's South Oak Cliff section. The Dallas theater was smaller, with a total seating capacity of about 1,160. Both theaters were designed by Earl J. Nesbitt Jr. The Austin Aquarius IV boasted the city's first fully automated projection booth. All four theaters were individually designed and color-coordinated from the carpeting down to the ticket stubs. They also had foam back seats, staggered for improved sightlines, with 40 inches of separation between rows to ensure adequate leg room. Below, the Podolnicks sit with their guests under the theater's signature lobby piece—an eight-by-eight-foot mural of Aquarius painted by Austin artist Richard Manz. (Right, AR.2012.004[033]; below, AR.2012.004[048].)

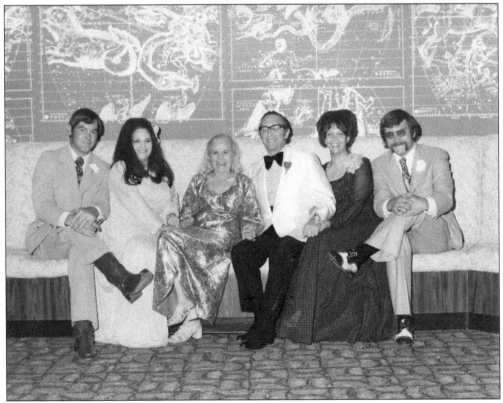

The four theaters shared a common lobby and concession area set up with dual equipment to accommodate large numbers of hungry customers. Note the Aquarian image on the wall above the auditorium doors in the photograph below. Off to one side of the lobby was a large television waiting lounge decorated with wallpaper made in Italy specifically for the theater featuring zodiac symbols copied from ancient texts. Shortly before the grand opening in May 1973, Lena Podolnick told the *Austin American-Statesman* that she named the new theater complex in honor of her husband's zodiac sign and for its proximity to Town Lake (now Lady Bird Lake). The Aquarius IV closed in 1996 and later reopened as the mini-mall El Gran Mercado. The building was recently demolished. (Above, AR.2012.004[057]; below, AR.2012.004[052].)

Five

INDEPENDENTS
AND DRIVE-INS

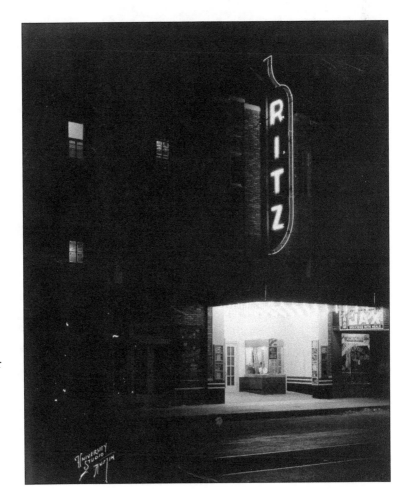

In addition to the
movie palaces and
chains, Austin
was home to many
independent theater
operators, from
the earliest days of
moving pictures
to the age of the
multiplex, such as
the Ritz Theater on
East Sixth Street.
(PICA 38440.)

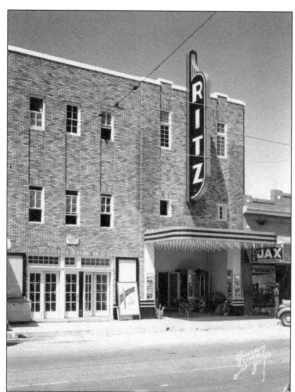

The Ritz was built by Jay J. Hegman in 1930 and remained a Hegman family enterprise until 1964. Hegman, originally from Galveston, had theaters in Galveston, Temple, Dallas, and Austin. The theater was on the edge of downtown, away from the main entertainment district. It was an independent theater, so it had difficulties getting first-run films. It showed mostly second-run "A" films, somewhat analogous to discount cinemas today. (PICA 38446.)

Within a few years, the Hegmans had the opportunity to expand the theater into neighboring space. The expansion, designed by Austin architect Hugo Kuehne and completed in July 1937, added 23 feet in width and 128 feet in length, creating a capacity of 800. It included a Western Electric Mirrophonic sound system and the newest American Seating Company Chairs. (PICA 38441.)

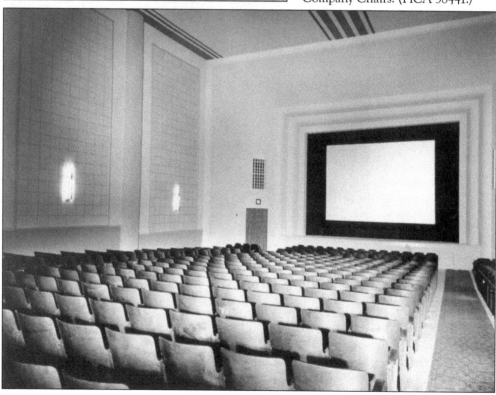

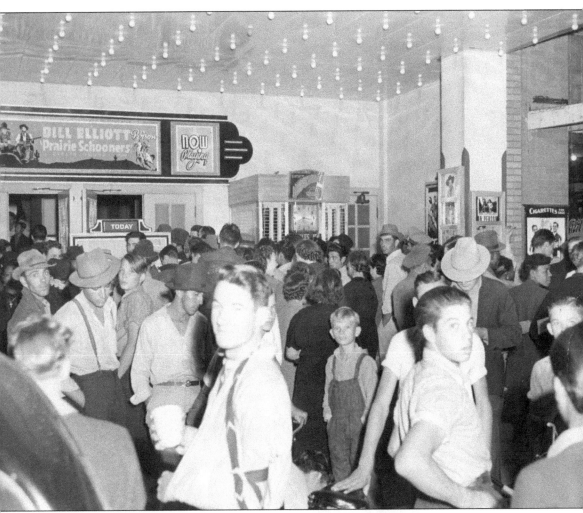

Though the theater did not usually show first-run films, it did exhibit Western films on a first-run basis and became the go-to place to watch a Western. Viewers were occasionally treated to a personal appearance by one of the stars, such as Bill Elliot, Columbia Pictures star of *Prairie Schooners*, appearing in November 1940. Other stars who made appearances included Tex Ritter and Ray Whitley. (PICA 38445.)

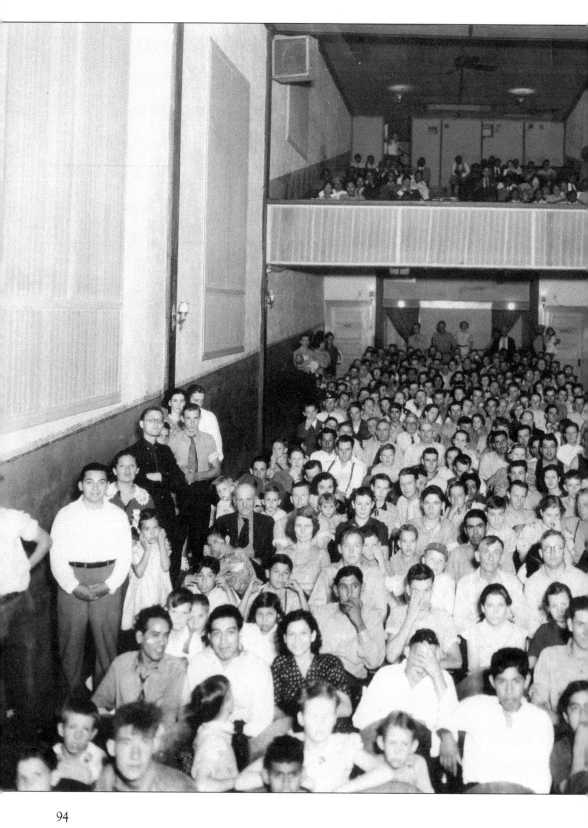

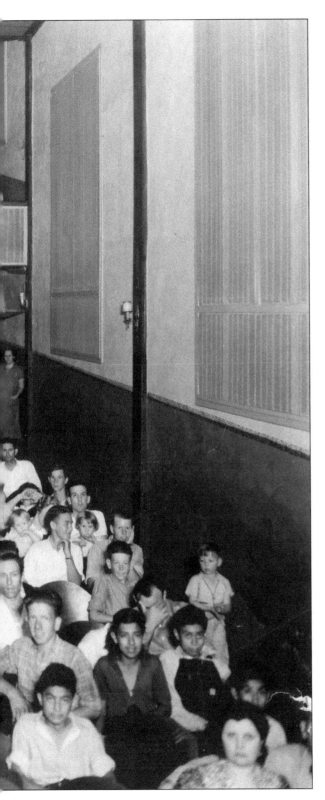

Crowds were a common site in the Ritz's early years, as seen here. But like many of Austin's downtown theaters, it began a slow decline in the late 1950s as more people moved to the suburbs (and stayed there to watch movies). The theater became the center of a local court case over obscenity charges when it showed adult films in the early 1970s. Jim Franklin and Bill Livingood took over operations in 1974, offering live music, theater, and films. Center Stage, a local theater troupe, also called the Ritz home for a time. (See chapter seven for its current fate.) (PICA 38443.)

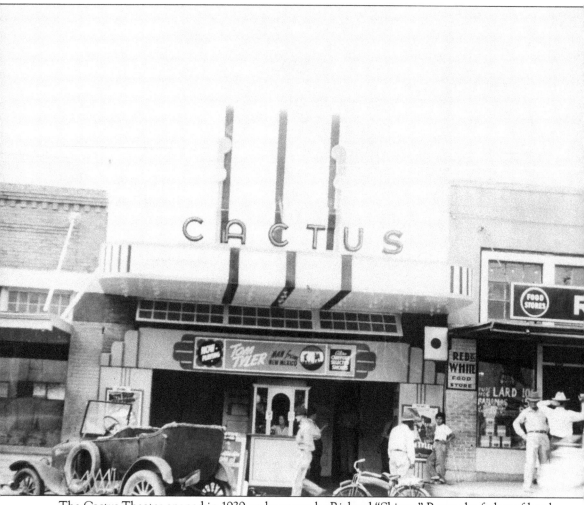

The Cactus Theater opened in 1939 and was run by Richard "Skinny" Pryor, the father of local broadcaster Cactus Pryor. It showed mostly second-run Westerns. Pryor was called a "year-round Santa Claus" for kids, always letting them in for free. He was born in 1885 in San Antonio and became a vaudeville performer. He came to Austin and ran the Texas Theater and Grand Central Theater (eventually renamed Skinny's) before opening the Cactus. There is a rumor that he nicknamed his son "Cactus" as a publicity stunt for his theater. He was known for introducing all the movies in his theater in person and sometimes singing a song or two before the show started. In 1951, Fred and Sam Lucchese took over the Cactus Theater and renamed it the Carver, serving primarily African Americans. The Carver closed in 1960 or 1961. It reopened in 1962 as an art film and porn theater run by Vernon Smith and fully integrated. (PICA 37207.)

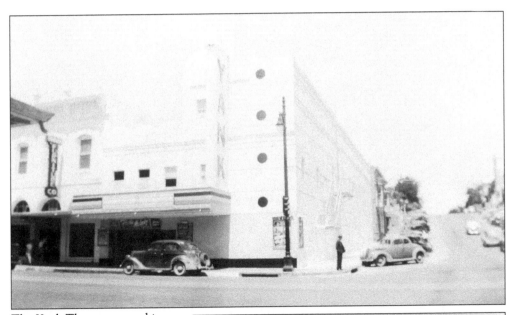

The Yank Theater opened in 1944 and showed mostly B movies. The theater was part of the chain operated by Eddie Joseph. Eddie was the son of Cater Joseph, a Lebanese immigrant to Austin. Cater had eight sons who were involved in numerous businesses around Austin, becoming one of the most prominent mercantile families in town. Eddie, in addition to his movie theaters, owned a commercial real estate company and a clothing store, the Campus Men's Shop. The Yank was later renamed Studio 4 and became an adult film theater. As Studio 4, it became embroiled in a legal case when the city raided the theater and arrested the staff for showing "obscene" material. The cases were settled in 1975. Studio 4 closed in 1973, and the building is now a dance club. (Above, PICA 36898; right, PICH 06522.)

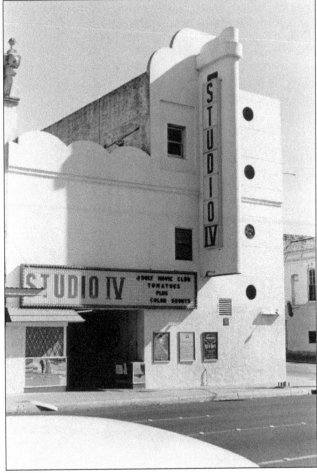

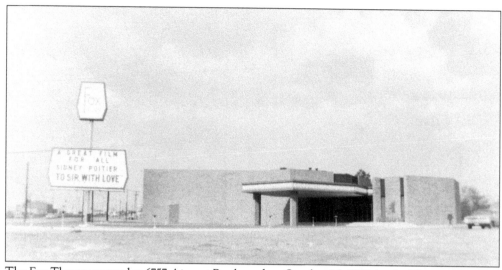

The Fox Theater opened at 6757 Airport Boulevard on October 26, 1967, by the National General Corporation (NGC). Though not an independent theater, it was the only NGC theater in Austin. The Fox opened with *To Sir, With Love* starring Sidney Poitier. The photograph below, taken shortly after the theater opened, shows projectionist Jim Maloy (right) and manager Joe Ungerliter. The Fox was converted to a twin on December 20, 1972, with Chill Wills as the ceremonial ribbon cutter. It closed on November 7, 1985, and is now the site of a Mercedes-Benz dealership. (Above, PICA 36814, below, ND-67-375/003.)

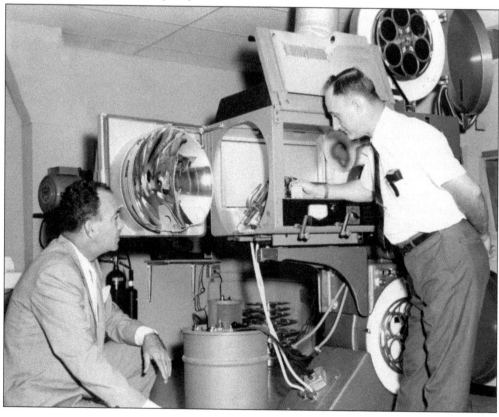

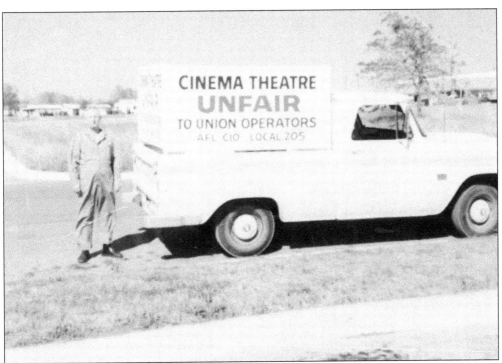

The Riverside Cinema Company opened the Riverside Twin Cinema at 1900 East Riverside in June 1973, serving primarily college students who lived in the East Riverside area. It immediately faced problems, being the victim of repeated vandalism and graffiti as well as picketing by union projectionists. (PICA 36860.)

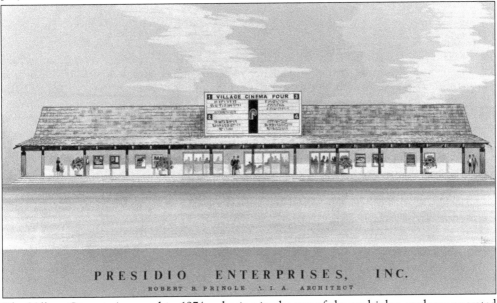

The Village Cinema 4 opened in 1974, ushering in the age of the multiplex, and was operated by the Austin-based chain Presidio Theaters. It later became Village Cinema Art and showed art films for over a decade before closing in 2001. Alamo Drafthouse bought it and reopened the theater as the Alamo North a few months after the arthouse closed. (PICA 09682.)

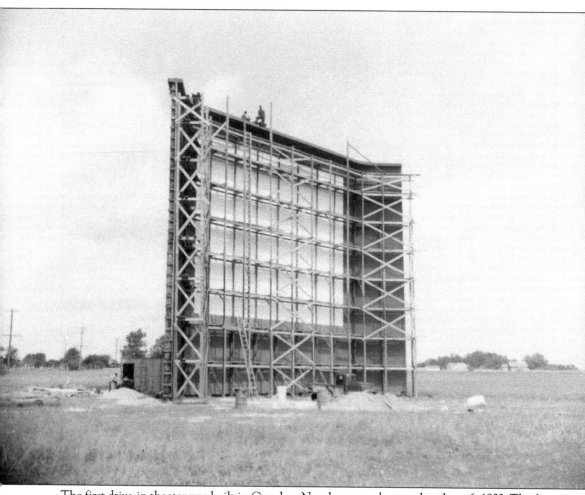

The first drive-in theater was built in Camden, New Jersey, and opened on June 6, 1933. The first in Austin (and Texas) was the North Austin, opening on November 18, 1940, at 6600 Dallas Highway (now Lamar Boulevard). Eddie Joseph owned and operated the theater, and also opened the Montopolis, South Austin, and Delwood drive-ins. Drive-in theaters were a short-lived phenomenon. Their demise was caused by a combination of factors: the rise of VCRs, daylight saving time, and the amount of real estate needed to run a drive-in versus a multiplex. A new drive-in theater recently opened in Austin called the Blue Starlite Mini Urban Drive-In Theater, a small "boutique" drive-in. Other Austin drive-in theaters not pictured include the Fiesta Drive-In at 1601 Montopolis Drive, the Longhorn Drive-In on Anderson Lane, and Showtown USA on Cameron Road. This photograph shows construction on an unidentified drive-in, possibly the Montopolis. (PICA 36895.)

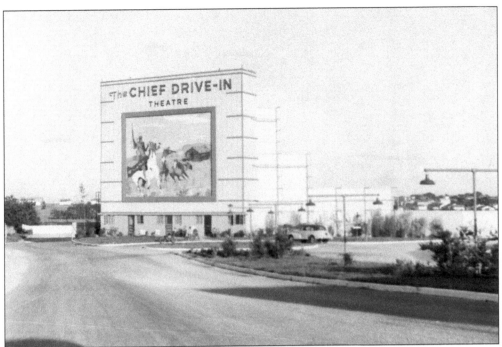

Probably the most well-known and beloved Austin drive-in was the Chief at 5600 Dallas Highway (now Lamar Boulevard), which had its gala opening on September 19, 1947, showing *The Virginian* starring Joel McRea and Sonny Tufts. It cost $300,000 to build and was designed by Frank Lopez (one source says Jack Corgan, a Dallas architect). The Chief had a capacity for 819 cars, as well as theater seating up front for those who did not want to sit in their car. The theater advertised the "world's finest snack bar" and featured individual speakers for every car with volume control. Underwood and Ezell Drive-In Theater Company opened and operated the Chief. The company had theaters all over Texas. (Above, PICA 36781; below, PICA 36847.)

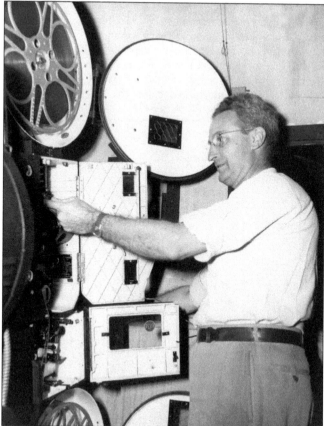

The theater also included a play park for children with swings, seesaws, and sand boxes. The Chief went out of its way to become "family-friendly," advertising bottle warmers for "mothers with infants" and opening a "family lounge" in 1960 featuring televisions and dining facilities. The Chief claimed to be "making it possible for a person to see TV while other members of the family look at the movie." (PICA 27708.)

Pete Myerly was the projectionist at the Chief at its opening in 1947. He may have been working there when they installed a Cycloramic fiberglass screen in 1954. At 40 feet by 80 feet, it was the second largest drive-in movie screen in the world, according to manager Glyn Morsbach. (PICA 36782.)

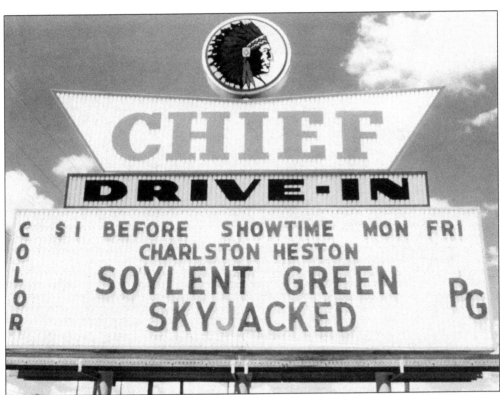

The Chief closed on July 24, 1973. The last showing was a double feature, *Soylent Green* and *Skyjacked*, both starring Charlton Heston. The site is now the Commerce Park Shopping Center. These photographs show the Chief on its last day as a theater. (Above, PICA 36771; below, PICA 36848.)

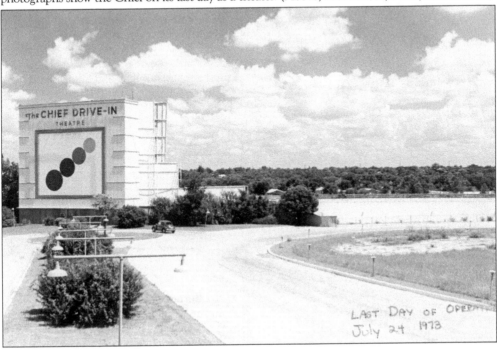

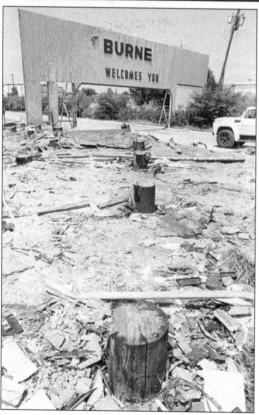

The Burnet Drive-In was built in 1950 by Charles Ezell & Associates and designed by Frank Lopez. It had a capacity for 750 cars and featured the first electric traffic control system that let drivers know where there were speaker vacancies. The initial admission prices were 50¢ for adults and 5¢ for kids. The first showing was *South Sea Sinner*, starring MacDonald Carey and Shelley Winters, and *Sitting Pretty*, starring Clifton Webb. (ND-54-494-06.)

The Burnet closed in April 1976. Within a matter of days, all the speakers were removed, and a trashed field was all that was left. (PICA 11522.)

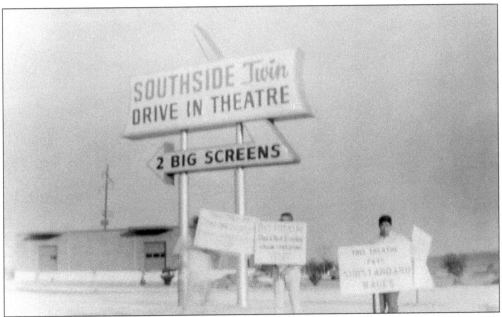

The Gulf States Theater Chain operated two drive-ins in Austin: the Showtown USA (in north Austin) and the Southside Twin (located at 710 East Ben White Boulevard). The Southside opened in January 1969 with a double feature of *Astro Zombies* and *Undertaker and his Pals*. In 1988, the marquee read, "Closed for the Winter." The theater never reopened, and the screens came down two years later. (PICA 36864.)

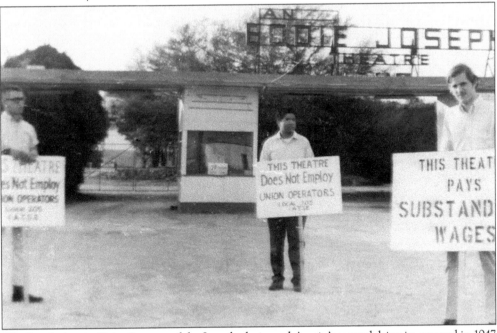

The South Austin Drive-In, part of the Joseph chain and Austin's second drive-in, opened in 1947 at 3900 South Congress Avenue (just north of Ben White Boulevard). It could accommodate 1,000 cars. Opening night featured *Smoky*, starring Fred McMurray and Anne Baxter. It closed in 1969. (PICA 36861.)

The Montopolis opened in 1947 and was one of Eddie Joseph's theaters. The films *Hi, Neighbor* and *13th Hour* were the double bill at the grand opening on September 19. It was located at 700 Airport Boulevard and closed in 1959. Joseph, proprietor of four drive-ins and one traditional theater, died in 1985. (AR.2009.042/WUK-5418.)

Six

SEGREGATION AND CIVIL RIGHTS

Austin, TX 1925

Like many other facilities in Austin in the early 20th century, movie houses were segregated. The Dixie Dale Theater was the first known theater in town opened specifically for the African American community. Joseph Trammell opened the theater in 1920 at 302 East Sixth Street. In 1922, A.C. Lawson (pictured) took over the Dixie Dale and renamed it the Lincoln Theater. It closed around 1929. (PICA 36899b.)

The Lyric, which opened in 1922, was the second-known theater in town to serve an African American audience. It was opened just one block east of the Lincoln at 419 East Sixth Street (where the Humpty Dumpty is in the photograph below) by dentist Dr. Everett H. Givens, pictured at left. Unfortunately, no photograph of this building while it was in use as a theater can be found. In the heart of the African American commercial district, it became a focal point for the community. A.C. Lawson took over the Lyric Theater from Dr. Givens and renamed it the Dunbar. It closed in 1931. (Left, PICB 03048; below, PICH 06544.)

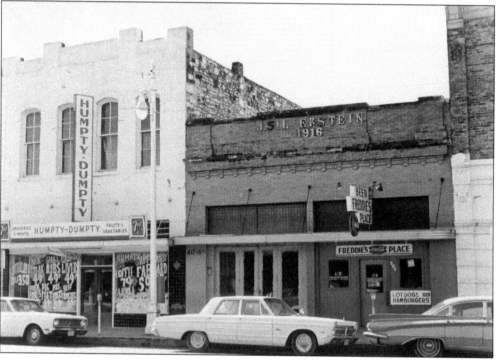

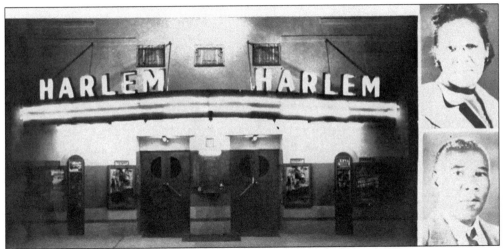

The Harlem Theater, located at 1800 East Twelfth Street, opened on October 5, 1935. George F. Jones, a Huston-Tillotson graduate, managed the Texas Auditorium at Prairie View College for 10 years prior to opening the Harlem. It was one of only seven black-owned and -operated theaters nationwide. Geroge's wife, Sadie, co-owned and ran the business with her husband. (Authors' collection.)

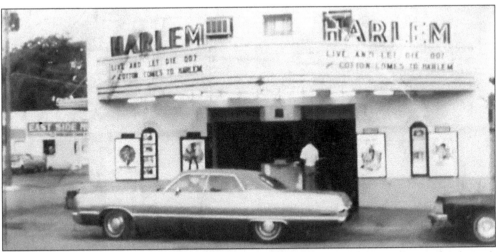

The Harlem exhibited first run Hollywood films, usually at the end of their run. It was also Austin's only outlet for all-black productions. The theater introduced a new concession idea called the Harlem Confectionery. In addition to traditional popcorn and candy, the Confectionery sold ice cream, chili burgers, pickles, and other fare and had outdoor garden seating for customers who wanted to eat there but not catch a show. (AR.2001.002[H-2].)

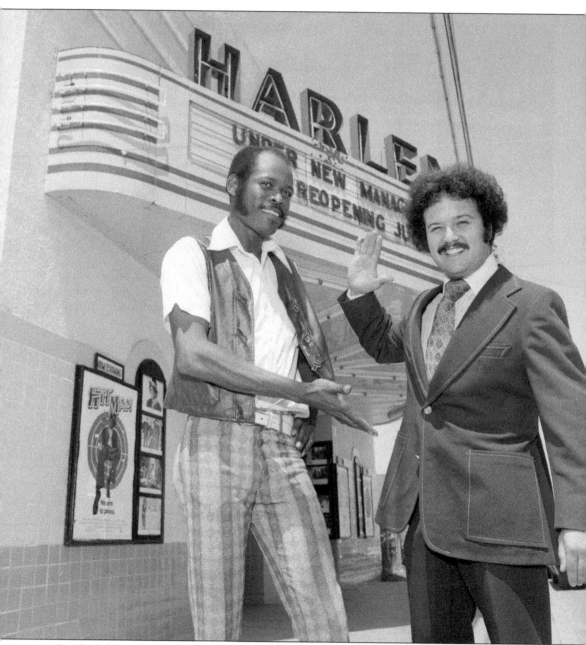

Frank and Sam Lucchese took over the theater after Jones died. They kept the same polices but were able to secure better movies. In July 1973, the theater reopened under the management of Willie Winn (left), Dennis D. Baum (right), and John Hutkin, with Winn serving as manager. It boasted a new screen policy, showing three films a week plus midnight shows on Fridays and Saturdays and "family-type" movies on Sundays. The grand reopening film was Hit Man, starring former NFL wide receiver Bernie Casey; the first midnight movie was Trick Baby. Unfortunately, the theater itself had a very short run, burning to the ground on December 30, 1973. (AS-73-84991.)

The first theater in Austin to integrate, to a degree, was the Ritz. As an independent, owner Jay J. Hegman had more leeway than many of the other theaters in town. It opened in 1930 with a "special balcony for negroes." The balcony had its own entrance and exit and was open to African Americans for all shows. (PICA 36821.)

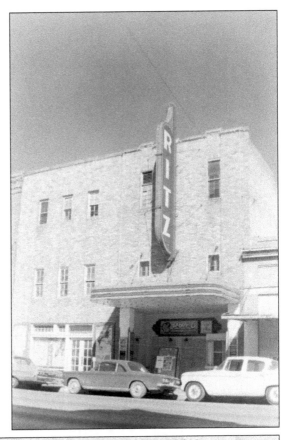

By the late 1930s, some Austin theaters, such as the Texas, located on "the Drag," a portion of Guadalupe Street next to the University of Texas campus, started offering "special showings" for African American and Mexican American patrons. The ITC theaters offered "colored" midnight shows, but there were no mixed seating arrangements. (AR.1999.016[188].)

AUSTIN, TEXAS

TEXAS Theatre JUEVES 11 de MAYO

La historia de dos amantes que llevaron su amor mas allá de la muerte, en una tierra de hombres íntegros incapaces de traición, pero poseídos de una maldita sed de venganza. ¡Poética evocación de un México legendario!

CLASA FILMS presenta a

Jorge **NEGRETE**

en UNA SUPER PRODUCCION MEXICANO

"**EL PEÑON** de LAS **ANIMAS**"

Dirección de MIGUEL ZACARIAS
Musica de Manuel Esperon
Letra de Ernesto Cortazar

María con **FELIX**
RENE CARDONA
Carlos L. **MOCTEZUMA**
MIGUEL ANGEL FERRIZ

...Además...
Un Buen Seleccionado Programa de Cortos!

CLASA-MOHME, Inc. Distributors of Mexican Films

June 20, 1944

Mr. Louis Novy
Manager, Interstate Theaters
City

Dear Mr. Novy:

On behalf of the members of the Lulac
Council of Austin and of the Latin-
American colony of Austin as a whole,
we wish to express our appreciation
to you and your company for the day-
time showing of Spanish films, and for
discontinuing the Saturday midnight
showing of said films.

We feel that this change of policy
on your part is a real effort toward
controlling delinquency in Austin and
a worth-while contribution to the
citizens of this city.

Sincerely yours,

Nash Moreno, President
Lulac Council

In response to a strong interest from the Mexican American community for better Spanish language film offerings, ITC manager Louis Novy began offering Spanish language films in 1944 on Thursday afternoons at the Capitol Theater, much to the appreciation of the League of United Latin American Citizens (LULAC) and the Mexican American community. (AR.2001.018/Box4Folder1Item1.)

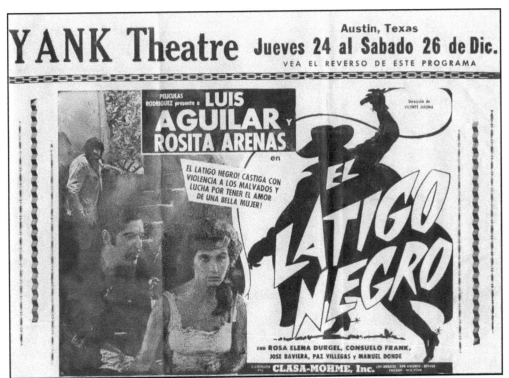

Eddie Joseph attempted to build a theater specifically for Mexican Americans in the 1940s, but wartime rationing prevented him. However, in 1944, he managed to open the Yank Theater, which showed mostly B movies as well as Spanish language films. This theater was part of a chain of movie theaters operated by Joseph. He was finally able to open a dedicated Spanish language theater, the Iris, in 1947. It was located just one block east of the Yank at 306 East Sixth Street and operated until 1955. (AR.1999.016[181].)

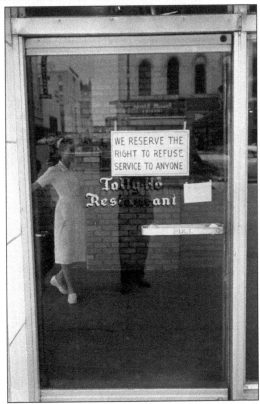

When the *Brown v. Board of Education* Supreme Court decision was handed down in 1954 declaring school segregation unconstitutional, many other organizations wondered if the ruling applied to them. ITC decided that the ruling did not apply to its theaters, as did most of Austin's others businesses such as the Tally-Ho Restaurant. It was located in the heart of downtown at Seventh Street and Congress Avenue. (AS-60-27281-08.)

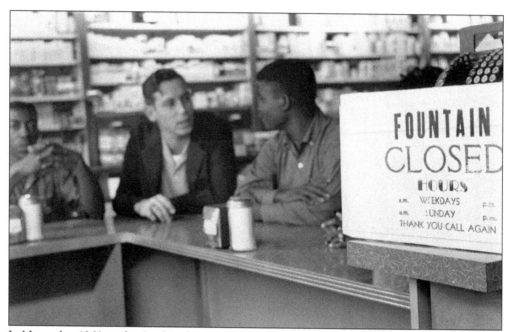

In November 1960, as the Civil Rights Movement began to sweep the country, a white University of Texas student, Chandler Davidson, organized the Students for Direct Action (SDA) to peacefully and lawfully integrate businesses along the Drag, the name for the strip of Guadalupe Street bordering the university campus. Having little success with integrating cafes and lunch counters, the group decided to turn its attention to movie theaters. (AS-60-27281-17.)

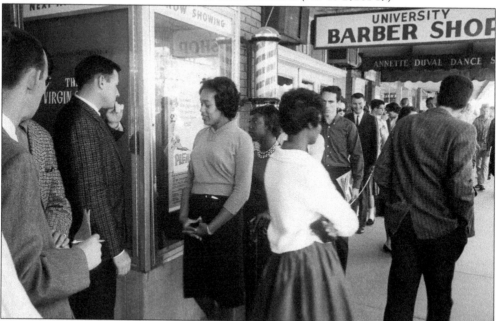

In early 1961, the SDA began a series of "stand-ins" (a variation on the "sit-in") at the Texas and Varsity Theaters, on the Drag. Protestors stood in line to purchase a ticket, and when refused, returned to the back of the line to try again. The intent was to get enough protestors in line to prevent others from buying tickets, thus denying revenue to the theaters. (AS-61-30610-47.)

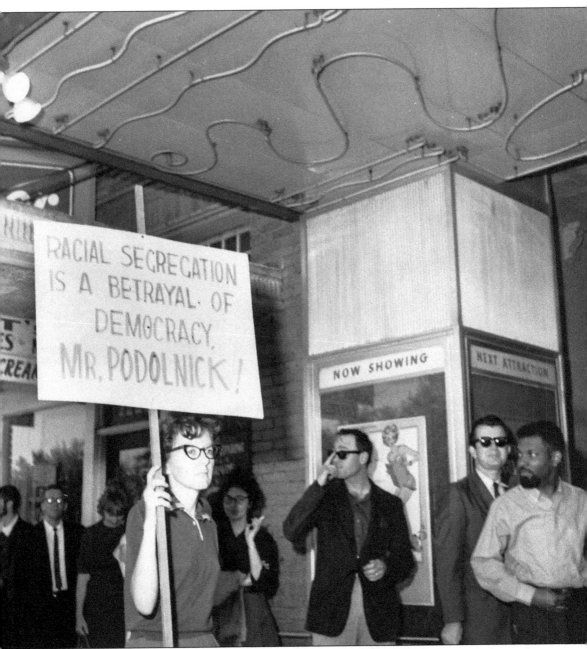

As protestors stood in line, picketers carried protest signs, like the one shown here, in front of the Texas Theater. At the time, the Texas was owned by Earl and Lena Podolnick's Trans-Texas Theaters Inc. This new form of protest began to garner national attention. Former first lady Eleanor Roosevelt, who was still publishing her nationally syndicated "My Day" column in her mid-70s, personally thanked the students "for making the effort to bring about the end of this kind of segregation." Stand-ins were soon being emulated nationwide. (AS-61-30610-37.)

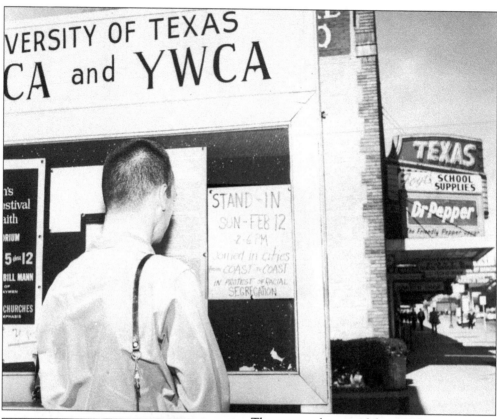

The most ambitious of the stand-ins was held on Abraham Lincoln's birthday, February 12, 1961. Hundreds of people lined Guadalupe Street in support as well as opposition. Similar protests were held that day in cities and universities across the country. Throughout the spring, the stand-ins continued to gain momentum. By September, the owners of both the Varsity and the Texas agreed to a one-month trial period in which African American university students were allowed into the theaters if the stand-ins agreed to stop protesting. The owners agreed to open their doors to all if their revenue was unaffected by the change in patronage. The trial period passed without a hitch, and within a year, most of the businesses along the Drag were integrated. Although it is unknown when all of Austin's other theaters integrated, it is likely that they, along with other businesses, followed suit by 1964. That year, Pres. Lyndon Johnson signed the historic Civil Rights Act, which outlawed discrimination in public facilities, including movie theaters. (Above, AS-61-30610-20; left, AS-61-30610-24.)

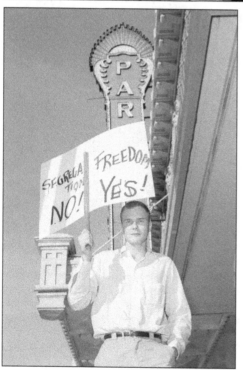

Seven

WHERE ARE THEY NOW?

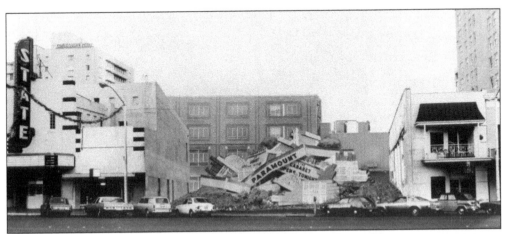

The fate of Austin's historic movie houses is varied, with many lost to history, some a testament to adaptive reuse, and a few that survive as theaters today. The crown jewel of Austin's theaters, the Paramount, was almost lost to history, as this staged picture seems to indicate. Fortunately for theater fans today, this was not the final fate of the Paramount. (PICA 30540.)

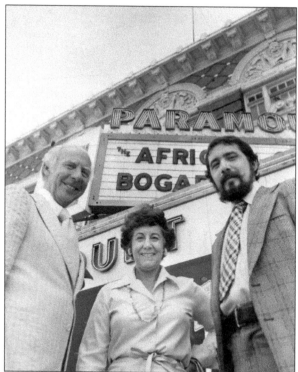

A new company headed by Jon Bernardoni (right), Chuck Eckerman, and Steve Scott, called Paramount Inc., formed in 1973 to save the theater, which was slated for demolition. Roberta Reed Crenshaw (center) deeded her 50 percent ownership of the property to the new nonprofit, putting the Paramount on the road to recovery. City manager Bob Tintsman is also pictured. (PICA 28493.)

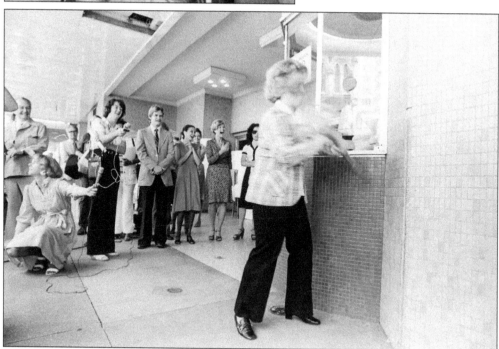

Ed Malcik, photographer for the *Austin American-Statesman*, took this photograph of Mayor Carole McClellan (now Carole Keeton) smashing the ticket booth window on September 21, 1977. The mayor's actions kicked off Paramount Inc.'s restoration project of the old theater, with a complete overhaul of the interior and exterior. (AS-77-97381A-03.)

The Heritage Society of Austin (now Preservation Austin) played a big role in the restoration of the theater. It gave a $20,000 grant to Paramount Inc. in 1976, one of the earliest donors to the restoration project. It also held fundraising galas, such as the event pictured here in 1976 where attendees celebrated in costume. The theater was listed in the National Register of Historic Places in 1976. (PICA 17316.)

Part of the effort to save the theater included staging special events, such as the world premiere of *The Best Little Whorehouse in Texas*, starring Burt Reynolds and Dolly Parton, in 1982. These events were part of a concerted effort to prove that the Paramount could still be a viable theater and performance space. (AS-82-2918-17.)

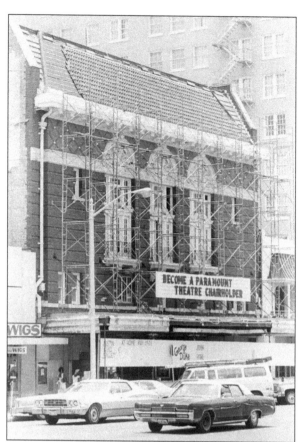

Of course, saving the theater meant restoring the building, which had fallen into disrepair after years of neglect. Paramount Inc. became the nonprofit Paramount Theater for the Performing Arts, and the company quickly started working on rehabbing the facility, as seen here in 1978. (Photograph by Pete Szilagyi, PICA 13346.)

On October 11, 2015, the theater celebrated its centennial. Part of the anniversary celebration included the installation of a new neon sign to replace the one taken down in 1964. Today, the restored Paramount is a premiere destination point in downtown Austin. (Photograph by Grace McEvoy, PICA 38621.)

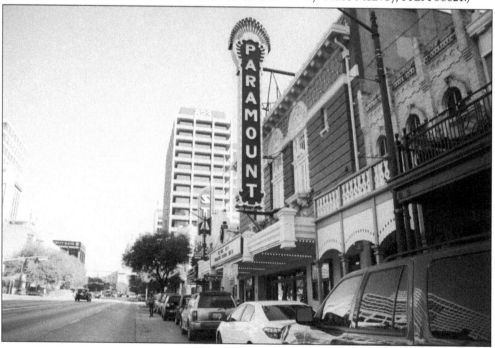

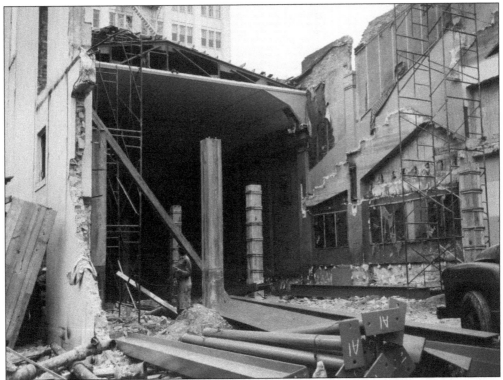

Sadly, the Queen Theater did not fare as well as the Paramount. During a show in 1952, part of the ceiling collapsed, injuring 20 children. The facade of the building was demolished, and by the end of 1955, this was all that was left of one of Austin's movie palaces. (PICA 26598.)

While the theater is gone, the shell and part of the Queen Theater building was saved. Arthouse at the Jones Center used the building as part of its facility, and the skeleton of the building can still be seen on the inside. This is now the Contemporary, renamed after Arthouse's merger with the Austin Museum of Art, which even shows the occasional movie in its rooftop garden. (Photograph by Grace McEvoy, PICA 38622.)

There is still some evidence of the nickelodeon days in Austin, with two of the original buildings still extant. The old Texas Theater was located on the first floor of the Bosche-Hogg building pictured at left, though much of the ground floor was changed in the 1980s. This is now an office building with multiple tenants. The Crescent Theatre's building at 920 Congress Avenue, pictured below, is home to Quick Draw Productions, a production company created by noted filmmaker Robert Rodriguez, as well as a couple private residences. (Left, PICH 09991; below, PICH 09991.)

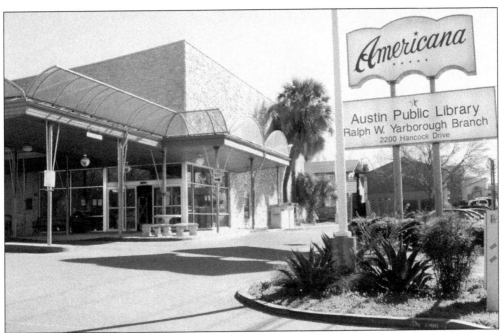

The Americana Theater is a great example of adaptive reuse for old buildings. While the community lamented the loss of their neighborhood theater when it closed, the Austin Public Library acquired the building and converted it into the Yarborough Branch Library. A portrait of Earl Podolnick hangs in the library to pay homage to the theater. (PICA 36792.)

The Southwood Theater, another Trans-Texas Theater building, still stands on Ben White Boulevard. It is home to the Blazer Tag Adventure Center, a popular laser tag game site and arcade. Other than the signage, the exterior of the building is mostly unchanged from its use as a theater. (PICA 36791.)

The Austin Theater has lived on in many roles. After its decline as a neighborhood theater, it was one of many theaters to show X-rated films during the adult cinema craze of the 1970s. Rechristened Cinema West, it continued as an adult theater well into the 1990s. It is now home to the advertising company adlucent, founded by Michael Griffin. (PICA 36790.)

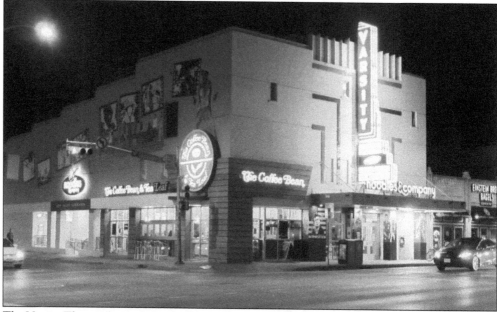

The Varsity Theater, long a favorite of University of Texas students and West Campus neighborhood residents, showed its last film on May 17, 1990. Tower Records occupied the building for many years before it was renovated in 2011 for its new restaurant tenants. The renovations involved creating a facsimile of the original 1970s mural and re-creating the original "Varsity" sign on the eastern entrance. (PICA 36789.)

The Cactus Theater building continues to entertain as home to Esther's Follies and the comedy club the Velveeta Room (the "cheesiest" place in town). (PICA 36793.)

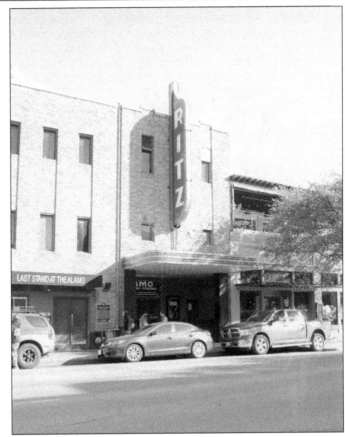

Though not a "palace," the Ritz joins the Paramount as one of Austin's restored theaters that is again a destination. Like many of its sisters, the Ritz fell into disrepair and disrepute, becoming an adult cinema in the 1970s and joining the decline of East Sixth Street in general. Tim League of Alamo Drafthouse bought and restored the Ritz in 2007, reopening it as the Alamo Ritz. (Photograph by Grace McEvoy, PICA 38623)

The Austin History Center is home to hundreds of photographs, oral histories, archival collections, and clipping files documenting the stories of Austin's historic movie houses. To learn more about the collections used to craft this book, check out the acknowledgements on page six and read the following page to learn more about the AHC. Pictured here are exterior and interior views of the AHC building. While not a historic movie house, the AHC houses many of their stories and has been known to show a film from time to time. (Above, PICA 28189; below, PICA 25449.)

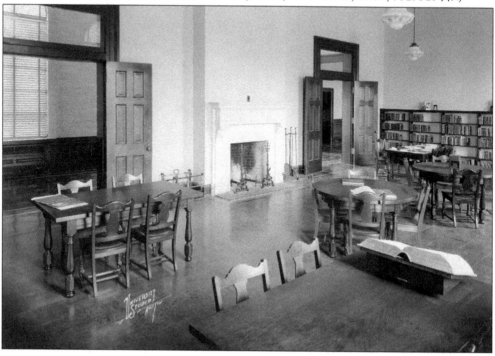

ABOUT THE AUSTIN HISTORY CENTER

The Austin History Center (AHC) is the local archives division of the Austin Public Library and is dedicated to preserving and celebrating the history of Austin and Travis County. The AHC is one of the premier local history collections in the country. It began in 1955 as a small collection of vertical file folders called the Austin-Travis County Collection in the Reference Department of the library and has grown to include:

Over 45,000 published books and City of Austin reports
Over 7,000 linear feet of archives and manuscript material
Over 1,000 historical maps
Over one million photographic images
Over 25,000 audio and video recordings

In addition, the AHC acts as the official archives for the City of Austin, caring for all historical and archival city records. The City Archives includes copies of city reports published by all departments; records of former mayors, council members, city managers, and assistant city managers; and records created by various city departments. The AHC procures, preserves, presents, and provides access to information about local government, businesses, residents, institutions, organizations, and neighborhoods in the Greater Austin area. MyTravelGuide calls the AHC "one of the state's best local history collections," Fodor's calls the AHC "a priceless collection of things relating to Austin, and *Library Journal* calls it "one of the premier local archives in the country."

The AHC is housed in the historic 1933 Austin Public Library building (Recorded Texas Historic Landmark and National Register of Historic Places), located at 810 Guadalupe Street in downtown Austin. Learn more at www.austinhistorycenter.org.

Visit us at
arcadiapublishing.com

CPSIA information can be obtained
at www.ICGtesting.com
Printed in the USA
LVHW111147200222
711572LV00012B/294